IMAGES
of America

FAULKNER
HOSPITAL

IMAGES
of America

FAULKNER
HOSPITAL

Cara Marcus

ARCADIA
PUBLISHING

Copyright © 2010 by Cara Marcus
ISBN 978-0-7385-7324-3

Published by Arcadia Publishing
Charleston SC, Chicago IL, Portsmouth NH, San Francisco CA

Printed in the United States of America

Library of Congress Control Number: 2009943996

For all general information contact Arcadia Publishing at:
Telephone 843-853-2070
Fax 843-853-0044
E-mail sales@arcadiapublishing.com
For customer service and orders:
Toll-Free 1-888-313-2665

Visit us on the Internet at www.arcadiapublishing.com

CONTENTS

ACKNOWLEDGMENTS

I would like to thank a number of individuals who have provided archival materials, assistance, remembrances, and support: Jeanne Arnold, Max Bermann, Barbara Biery, Rebecca Blair, Janet Bond, Glenna Bridges, Susan Briggs, Mark Bulger, David Cahan, Elise Madeleine Ciregna, Elaine Cohen, Leo Cohen, Debby Cole, Liz Condakes, Mike Conklin Jr., Amiel Cooper, Jean Crimmins, John Dantona, Dave D'Apice, Ellen Dobbyn, Jack Eckert, Robert Eyre, Mary Fallon, Aleric Faulkner, Herbert Kimball Faulkner, Jennifer Fauxsmith, Elizabeth Fitzpayne, Alison Foley, Anne Forbes, Zeljko Freiberger, Frank Frey, Ann Gessner, Donna Girard, Peter Goff, David Goldberg, Peggy Goode, Judi Greenberg, Gretchen Grozier, Harley Hammerman, Elizabeth Hanson, Erling Hanson Jr., Hannah Helfner, Sasha Helfner, Laura Henry, Chrissie Hines, Mary Hourihan, Jonathan Hubbard, Andrew Huvos, Mimi Iantosca, Ruth Imbaro, Peter Faulkner Jeffries, Stephen Benjamin Jeffries, Jennifer Johnston, Paul Keating, Maryalice Kenney, Pardon Kenney, Margaret Faulkner Kingsbury, Deb LaScaleia, Jeffrey Lane, Emily Levine, Leonard Lilly, Elizabeth Loder, Laura Machlin, Betty Mahoney, Phillip Malleson, Ed Marcus, Mary Maresca, Dolly Marmol, Tracy Marshall, Mary Martin, Daniel Matloff, Nancy Mayo-Smith, Sophia McBrine, Karen McGrath, Cindy Messia, George Milley, Irwin Mirsky, James Morgan, Raymond Murphy, Joan O'Connor, Brian Panella, Kenneth Pariser, Kay Pfau, Kenneth Potts, Anne Quinlan, Alberto Ramirez, Paul Rizzoli, Erin Rocha, Eugenia Romanos, Larry Rosenberg, Norman Sadowsky, Anthony Sammarco, Aaron Schmidt, Rosemarie Shortt, Madeline Smith, Anne Vanderheyden Stacy, Andy Stamer, Janice Stetz, Brian Sullivan, Susan Symonds, David J. Trull, Scott Vanderhoof, Ruth Waitz, Jessamine Gordon Warren, James A. Warth, Michael Wilson, and Stephen Wright.

Unless otherwise noted, all images are from the archives of Faulkner Hospital.

INTRODUCTION

Faulkner Hospital is a pictorial narrative that takes the reader on a voyage back in time. Faulkner Hospital, located in Boston, Massachusetts, is a nonprofit, 150-bed hospital built in 1900. The vast hospital archives, located in the Ingersoll Bowditch Medical Library, transport the reader from Kingsclere, England, to colonial Massachusetts to learn about the Faulkner family, then on a fascinating exploration of Faulkner Hospital's numerous clinical and educational advances throughout its first century. The hospital is world-renowned for its Centres of Excellence, the Faulkner-Sagoff Breast Imaging and Diagnostic Centre, and the John R. Graham Headache Centre, and is highly regarded as one of the region's most respected community teaching hospitals.

When the hospital first opened its doors, a twice-a-day hospital barge and horse-drawn carriages brought patients to cozy rooms with fireplaces. Charges for private rooms were only $3 to $5 a day, and six beds were free. Progress in medicine soon made Faulkner Hospital into a large teaching hospital with training programs for students from Tufts University School of Medicine and Harvard Medical School. Faulkner Hospital also established thriving medical residency, fellowship, internship, and continuing medical education programs. For over 70 years the hospital operated a training school for nurses, which was registered in both Massachusetts and New York State. Many students continued to work and live in residence apartment buildings at Faulkner Hospital after graduation. Graduates from Faulkner Hospital educational programs have gone on to become leaders in their field.

Numerous medical milestones have been achieved at Faulkner Hospital, such as the first-ever intrauterine transfusion, the founding of one of the original four cardiac rehabilitation centers in Massachusetts, and first use of laser treatment for esophageal cancer in Boston. Medical landmarks at Faulkner Hospital include research by Dr. Kenneth Pariser on the connection between headaches and Raynaud's Syndrome and Dr. Raymond Murphy's work on a computer-based system to analyze heart and lung sounds.

Faulkner Hospital doctors, nurses, and staff have saved the lives of countless individuals, treating victims of early electric trolley car accidents, riders thrown from racehorses, and survivors of a derailed train. Doctors at Faulkner Hospital saved the life of a boy who fell through the ice and was trapped underneath it for 20 minutes. Faulkner's community of caring has extended to vases of flowers placed at patient bedsides to Bravo Awards for staff who have gone above and beyond in their efforts to provide the very best in patient care.

The hospital has always been an integral part of the communities it served, providing patient lectures through radio broadcasts, a Healthy Conversations Speaker's Bureau with community lectures on timely health topics, an x-ray training for the blind program, one-of-a-kind art exhibits all about headache pain, and murals to depict breast cancer survivorship.

Many individuals have volunteered their time and skills to help Faulkner Hospital provide exemplary care, from the early Cutting Committee (who helped make garments, linens, towels, and even bandages) to the Aid Association (later named the Auxiliary) that raised money for patient

care through rummage sales, tag sales, and bridge parties. The hospital implemented programs for seniors and people with disabilities, such as Lifeline, an innovative emergency response system with a direct connection to the Faulkner Hospital Emergency Room.

Faulkner Hospital continued to expand throughout the years, acquiring nursing homes and physician associations and offering walk-in, express-care clinics to the surrounding areas. In the 1990s, the leadership of Faulkner Hospital and Brigham and Women's Hospital began to explore ways to collaborate and joined to become Brigham and Women's/Faulkner Hospital in 1998. This work set the stage for considerable investment in systems, equipment, and movement of major clinical programs to the Faulkner campus.

What makes Faulkner special? Dr. Norman Grace, who came to Faulkner Hospital in 1968 as a staff physician and became the hospital's first chief of gastroenterology in 1971, is very fond of Faulkner Hospital and has pleasant memories of afternoon teas where the medical staff would brainstorm on ways to improve the services. Dr. Irwin Mirsky, an oral maxillofacial surgeon who came to Faulkner Hospital in 1959, remembered how the end operating room in the original hospital opened to a breathtaking view of the city of Boston. Glenna Bridges, who started working at Faulkner Hospital in radiology in 1973, appreciated the flexible shifts and expressed that the people have been great. "What has always characterized Faulkner Hospital?" mused Dr. Norman L. Sadowsky, chief of radiology. "It is our attitude toward our patients. Our attitude is one of empathy and compassion. We are truly patient-centered. The people who work here reflect the ideal of what taking care of a patient really means. Everything we do is geared toward alleviating the patient's anxiety. When I see a person come in here, I think of her as a relative and care for her in that manner."

Images in the book chronicle the growth and development of the hospital, while focusing on what has made it a unique place to work and receive medical care. From the hospital's splendid sun parlors of the early 1900s to the gala centennial celebration of 2000, readers will enjoy following Faulkner Hospital's many milestones.

One

THE FAULKNER FAMILY

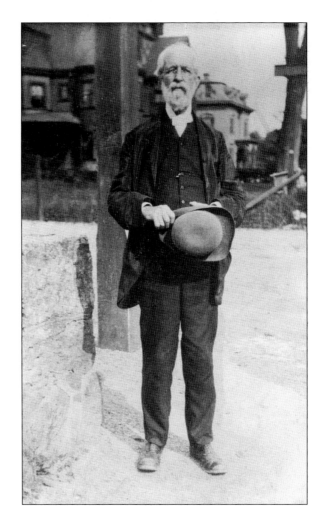

The story of Faulkner Hospital begins with the Faulkner family. George Faulkner, son of Francis and Ann Faulkner, was born at Billerica, Massachusetts, on July 14, 1819. He was the youngest of 12 children, six of whom were born in Watertown, two in Shirley, and four in Billerica. All the Faulkners lived to maturity, nearly all to old age, and nine married.

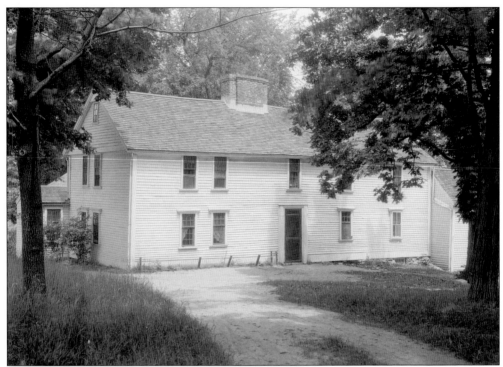

The Faulkner Homestead is the oldest building in Acton. The 1707 Colonial blockhouse with oak beams is listed in the National Register of Historic Places. The house served as a garrison for protection from Native American raids during the Queen Anne's War and was a garrison again during the Revolutionary War. (Courtesy of American Antiquarian Society.)

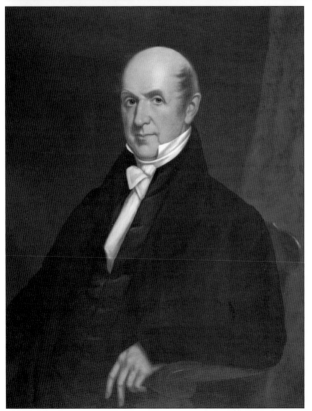

George's father, Francis Faulkner, was believed to be the earliest manufacturer of woolens in this country, establishing Faulkner Mills in Acton. Faulkner Street in Billerica is named after him. Francis Faulkner was one of 11 children of Col. Francis Faulkner, who fought in the Battle of Lexington during the Revolutionary War and served as a member of the Provincial Congress. (Painting by Henry Cheever Pratt; courtesy of Billerica Historical Society.)

The colonel's father was Ammi Ruhammah Faulkner of Andover. Ammi Ruhammah was the child of Lt. Francis Faulkner and Abigail Dane Faulkner, who was convicted of witchcraft in the Salem Witch Trials of 1692. She was spared hanging because she was pregnant with her seventh child. The name Ammi Ruhammah, of biblical origin, means "my people have obtained mercy" because he had saved his mother's life. (Courtesy of Scott Vanderhoof.)

The family lineage has been traced to Kingsclere, England, with different spellings over the years. Edmond Fawconer immigrated to Salem and purchased the town of Andover for six pounds and a coat. The Kingsclere Historical Society traced the Fauconer family to the year 1263, when the name of Ralph Fauconer occurs in a grant relating to the St. Mary Bourne Church, pictured here. (Courtesy of the Archives of the Kingsclere Heritage Association.)

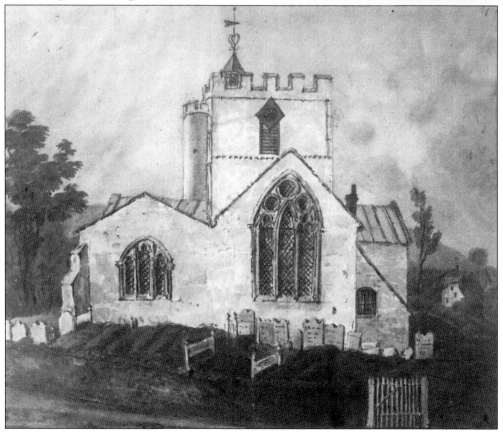

The family name has been recorded as Falconer, Fauconer, Fauckner, Faukoner, Faulkener, Faulknor, Fawconer, Fawkenor, and Fawkner. Faulkner is a British name for someone who keeps and trains falcons. Edmond Faulkner bore arms of "sable, three falcons argent, belled." The Faulkner crest appeared in *Matthews' American Armoury and Blue Book*. In Kingsclere, the Falcon Inn dates back to Shakespeare's time, and there is a Fawkoner Road. (Courtesy of Mainframe Photographics.)

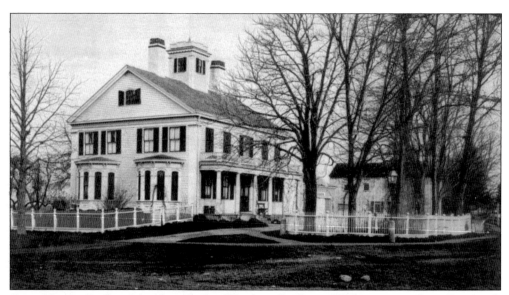

One of George Faulkner's brothers, Luther Winthrop Faulkner of Billerica, owned a mill in South Lowell. His wife, Martha, wrote a letter encased in a bottle describing trees in Billerica. One tree was planted at the Luther Faulkner House, pictured here. The house became a well-known landmark, and one of its future owners even replanted versions of the original trees that were lost in storms.

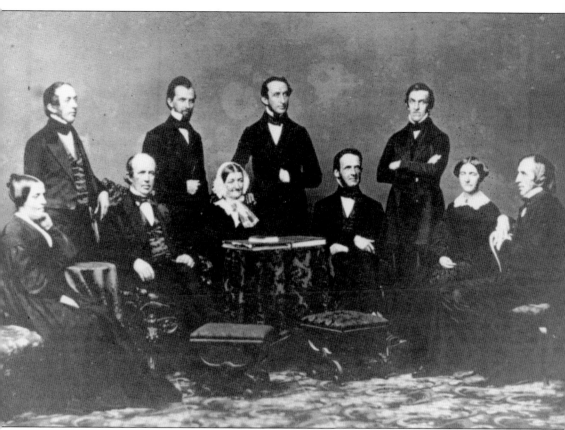

The children of Francis and Ann Robbins Faulkner, the fifth generation of the family living in the United States, are shown in this photograph. From left to right are Lois, William, James Robbins, George, Ann E., Charles S., Dwight F., Winthrop, Lydia H., and Luther Winthrop Faulkner. James Faulkner took over the Faulkner Mills and founded the Faulkner Kindergarten in Billerica. Two of Charles Faulkner's children became physicians. There was also another Charles Faulkner who was a founding member of the board of managers for the Children's Hospital Boston and who was instrumental in its governance. The Faulkner family is also related to Ralph Waldo Emerson, as Winthrop was Emerson's grandfather. Other distinguished relations to the Faulkner family include two uncles of George Faulkner who became congressmen and a cousin, Benjamin R. Curtis, who served as judge of the Massachusetts Supreme Court.

George Faulkner studied at Billerica, Westwood, Leicester, and Phillips Academies and Harvard College. He spent one year with famous surgeon, Dr. Amos Twitchell, then returned to complete his medical studies. He received his M.D. from Harvard Medical School in 1847. Dr. Luther M. Harris gave up his practice to George Faulkner. Dr. Faulkner soon found himself in possession of an excellent practice in Roger's Drug Store on Centre Street. (Photograph by Allen and Rowell.)

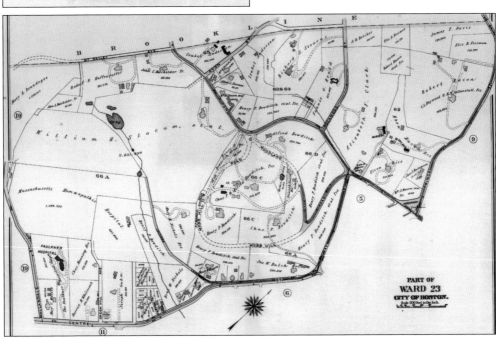

This G. W. Bromley and Company map from 1905 shows Faulkner Hospital and the addresses of many of its founders. Dr. Faulkner moved a number of times, living on the corner of Maple Place and Seaverns Avenue, then on Pond Street, and finally at Greenough Avenue. Dr. Faulkner's home was situated near a sheet iron store, a dry goods store, and a brewery. (Courtesy of WardMaps LLC.)

Dr. Faulkner continued in active practice until 1875. For many years, Dr. Faulkner was one of the leading physicians and prominent citizens of West Roxbury. He was skillful, tactful, and popular and was often called in for consultations. He was said to show the utmost public spirit as a citizen. Dr. Faulkner was heralded as a legendary physician by the Jamaica Plain Historical Society. (Courtesy of Jonathan Hubbard.)

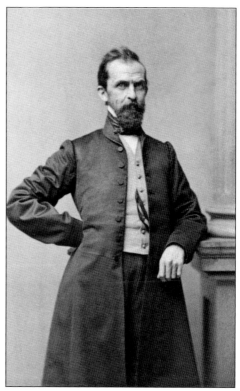

George Faulkner married his first wife, Mary Ann Spaulding, on the day he received his degree in medicine in 1847. Their first daughter, Mary W. Faulkner, was born in 1852 and lived over five months. Their second daughter, Mary S. Faulkner, died at nearly five months of age in 1854. These infants succumbed to cholera infantum and dysentery. Mary Faulkner, born in 1859, was George and Mary's third daughter.

After Mary died in 1869, George Faulkner married his second wife, Abby Larkin Adams, in Jamaica Plain in 1870. Abby was the adopted daughter of Abel Adams, a wealthy and prominent merchant of Boston, and Abby Adams. Abby Faulkner inherited a fortune, which she dispensed generously to various causes. She was also an officer of the Corporation of the Massachusetts Infant Asylum. (Photograph by Allen and Rowell.)

Abby Faulkner came to love her stepdaughter dearly. Dr. Faulkner's carriage was a familiar sight with his Scottish Terriers and Mary accompanying him. Mary, who only lived to be 37, died in 1896 and was one of the first people in Boston to be cremated. She was said to have inherited her father's ability, honesty, and good sense as well as his profound sympathy for the poor and the unfortunate.

Ellen Morse shared her reminiscences of George Faulkner with the Tuesday Club: "I recall my first acquaintance with Dr. George Faulkner. While he made his calls, the mother gave the little girl her first schooling or read to her. Well, we remember the calls of that good physician: his every kindly presence in the sickroom and his helpful, cheery words in the homes of anxiety and care." (Photograph by Whipple.)

Abby Faulkner died on January 5, 1900, and was cremated. The *New York Times* personal notes stated, "The late Mrs. Abby L. A. Faulkner of Jamaica Plain. Mass., bequeathed all her property for the erection of a hospital there 'for the people' on the death of her husband, Dr. George Faulkner. She had purchased a site for it." (Courtesy of Jonathan Hubbard.)

Long before her death, Abby Faulkner had conceived the idea of a hospital in remembrance of Mary, whose life was devoted to benevolent works. When Abby died, a trust fund was set up to build Faulkner Hospital as a memorial to Mary. The sums provided to the hospital under this trust amounted to $237,817.89 from Abby Faulkner's estate and $248,021.30 from Dr. Faulkner's.

Charles and Alfred Bowditch executed Abby's will. She had entreated them to name the hospital "The Mary Faulkner Hospital" in memory of her beloved daughter. Plans for the hospital were reported by the Massachusetts Medical Society: "It is probable that it will contain a medical and a surgical ward, as well as out-patient and convalescent departments." In 1900, Faulkner Hospital was incorporated with funds received from Dr. George Faulkner and Abby Faulkner's estate.

To the Executors of my will Charles P. Bowditch and Alfred Bowditch Esquire

Dear Friends,

I had intended to request you when the time should come for the building of a Hospital to make it The Faulkner Hospital but now I entreat you to call it The Mary Faulkner Hospital in memory of my beloved daughter Mary

Abby A. Faulkner

May 1st 1896

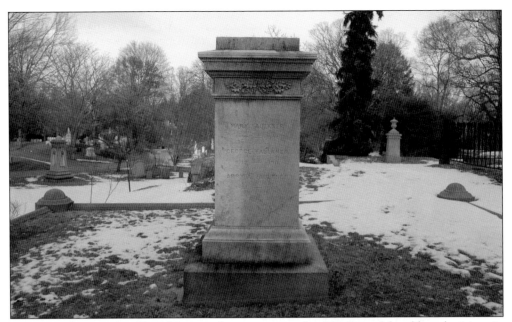

George Faulkner outlived his siblings and was active into his 90s. One of the oldest physicians in Boston, he died in his home in 1911 and was cremated. His remains were buried at Mount Auburn Cemetery alongside his wife, Abby, and his daughter, Mary, surrounded by weeping beeches and Waldstemia fragarides. The acorns that adorn the monument portray a sense of heartiness and endurance. (Courtesy of Mount Auburn Cemetery.)

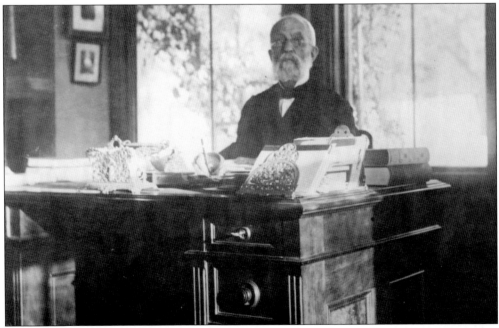

Dr. Faulkner's cheery optimism and kindly presence in the sickroom dispensed comfort real as any medicine. "Comfort, support, and cheer your patient" was his maxim. There was a Scottish dominie whose words he loved to quote: "Be the change which death brings what it may, he who has spent his life trying to make this world better can never be unprepared for another."

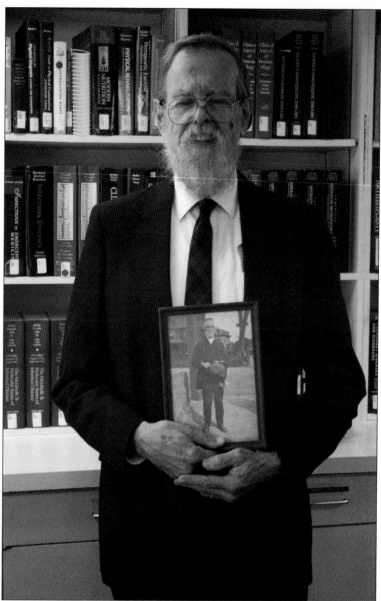

Many members of the Faulkner family have remained in touch through annual reunions and Web sites devoted to family news. A very special reunion was held at Faulkner Hospital on September 10, 1960—a memorable day of tours, presentations, and festivities. Margaret (Rita) Faulkner Kingsbury compiled a comprehensive genealogy of the descendents of Edmond Faulkner, with nearly 600 pages detailing 11 generations. The current generations of the Faulkner family are active in the world of medicine and include physicians, registered nurses, laboratory technicians, dentists, x-ray machine salesmen, medical school professors, psychologists and psychiatrists, surgeons, certified nursing assistants, and occupational therapists. Many descendents have taken a keen interest in the family's history, such as Kathleen Benner Duble who wrote a children's novel called *The Sacrifice* that tells the story of Abigail Faulkner and the Salem Witchcraft Trials. This photograph shows George Faulkner's third great nephew, Dr. Peter Jeffries, holding a photograph of Dr. George Faulkner during a visit to the hospital in 2009.

Two

A Look Back in Time

Looking out beyond Faulkner Hospital to the rolling hills and trees of the surroundings, it is easy to imagine how serene and lush the area was. Centuries ago, the Massachusetts tribe fished in Jamaica Pond and hunted for deer or moose. When the first settlers came, they were greeted by a landscape filled with pristine ponds and cascading foliage. (Copyright ©Leon H. Abdalian; courtesy of Boston Public Library.)

Jamaica Plain was once part of the Town of Roxbury, originally called Rockberry for the rockberry puddingstone formations found there. Roxbury Puddingstone (pictured) is the official rock of Massachusetts. Jamaica Plain was first called "the Pond Plain," referring both to Jamaica Pond and the type of land that surrounded it. It had also been referred to as "Jamaica End" and "Jamaica or the Pond Plaine." (Courtesy of Mainframe Photographics.)

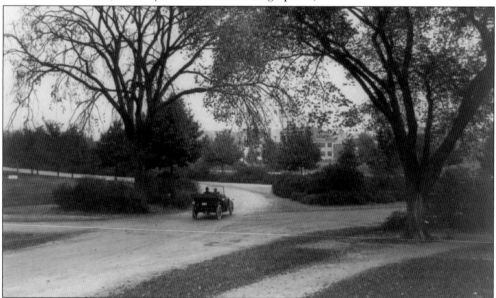

Centre Street was first laid out in 1663 and is one of America's oldest roads. The street was first known as "Dedham Road." Portions were called Austin Road in honor of Arthur W. Austin, a prominent attorney, and Walter Street, after Rev. Nehemia Walter. The street was permanently renamed Centre Street in the 1870s. This photograph of Centre Street is from 1914. (Copyright ©Leon H. Abdalian; courtesy of Library of Congress LC-USZ62-98782.)

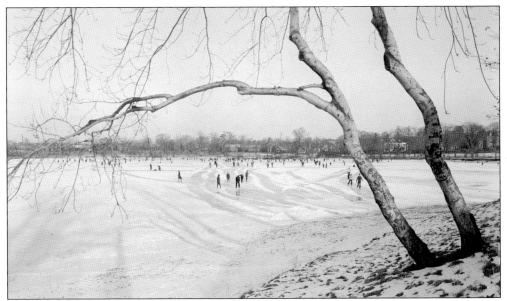

Jamaica Plain was a vibrant neighborhood at the beginning of the 20th century. The residents were active in business, attended community events such as sports contests and parades, and gathered on the shores of Jamaica Pond for annual occasions like Fourth of July festivities. (Copyright ©Leon H. Abdalian; courtesy of Boston Public Library.)

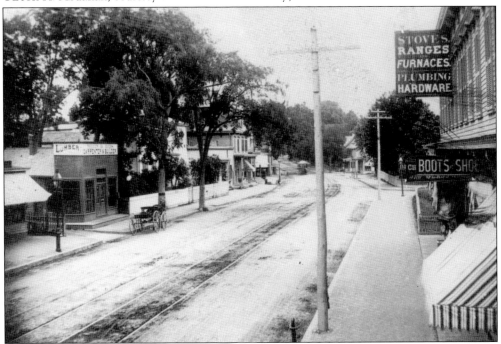

Dr. George Faulkner's first practice was at C. B. Rogers and Company Pharmacy in this area of Burroughs Street. In 1900, Jamaica Plain was in the midst of an epidemic of the grippe, a form of influenza. The local papers were peppered with advertisements for remedies for coughing and breathing problems, and one could even purchase "fresh aerated milk from tuberculin tested cows." (Courtesy of Boston Public Library.)

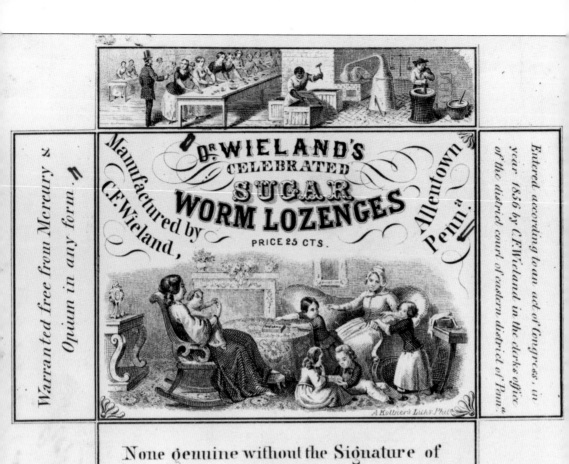

What was medicine in America like in the 1800s? Imagine a time when family practitioners like Dr. George Faulkner made house calls by stagecoach. Anna L. Manning, a Boston Public Library librarian who wrote an extensive history of Jamaica Plain and West Roxbury, recollected the 1870s, when medicine men and "rainwater doctors" practiced in this area. She had fond memories of Dr. Solomon's Vaudeville Troup visiting West Roxbury each May. The troup set up their stage, lighted by gasoline torches, and put on a fine show filled with singers and clowns. At the end of the show, Dr. Solomon sold his painkilling tonic for $1 a bottle, and anyone who bought a bottle could also have a tooth pulled out for free. In a business directory hailing from 1873, Jamaica Plain was home to homeopathic and magnetic physicians, apothecaries, and druggists, along with a sizable number of boot and shoemakers, curriers, carriage smiths, and wool pullers. This advertisement shows a popular remedy for many ills from the mid-1800s—worm lozenges. (Copyright ©C. F. Wieland, 1856; courtesy Library of Congress, LC-USZ62-102488.)

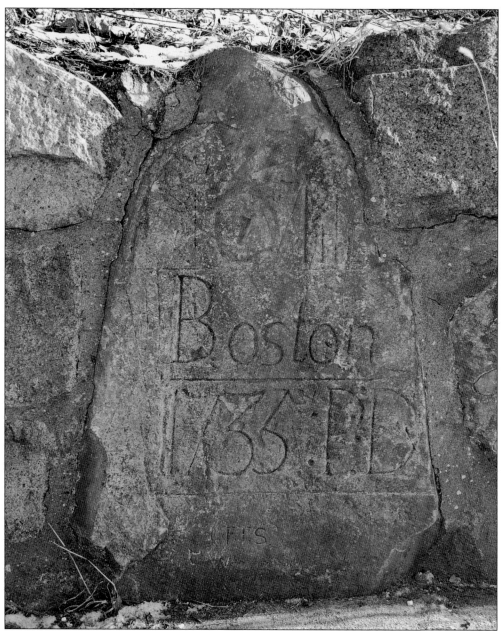

The Peacock Tavern stood on the corner of Centre and Allandale Streets in 1735 before the Faulkner Hospital was built. Identified by the Judge Paul Dudley milestone, it was a lovely inn, which was renowned for its great food and cheer. The attractive building boasted a large porch, wide doorways, and a colorful sign with a peacock painting on it. When the Revolutionary soldiers (including George Washington) were in Boston, they frequently enjoyed skating parties on Jamaica Pond and often ended the day at this tavern. John Hancock used to frequent the tavern in the summertime. The first "keeper of the inn" was Capt. Lemuel Child. Samuel Adams bought the tavern in 1794. The marker, a triangular-shaped stone in a rock retaining wall on the easterly side of Centre Street, is still visible near the sign for the Arnold Arboretum. (Courtesy of Mainframe Photographics.)

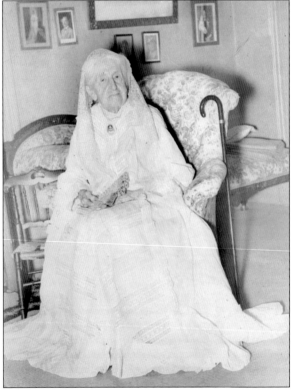

In the 1600s, the property that Faulkner Hospital now occupies was owned by one of the area's first settlers, "Freeman" Edward Bridge. The next building on the property was the home of merchant Mordecai Lincoln Walls. In the 1800s, Mary Wallis, Isaac Hall, Harriet Whitcomb, and Charles Manning owned properties on the grounds. The Wallis House (shown here) stood on the property until 1953. (Courtesy of Boston Public Library.)

Harriet Manning Whitcomb's residence was once known as the Manning Homestead of Manning Hill. The Whitcomb House remained on the property until 1963 and was also used as classrooms and student residences, as was the Wallis House. This photograph shows Harriet Whitcomb at age 100; she lived to be 102. Whitcomb Street, adjacent to Faulkner Hospital, was named after the family. (Courtesy of Boston Public Library.)

The hospital site, on the corner of Centre and Allandale Streets, was chosen by the founders. Faulkner Hospital is situated on Green Hill, the second tallest hill in Boston. The hospital afforded important sanitary advantages with its location on a high, southerly slope of 7 acres opposite the spacious grounds of the Arnold Arboretum and its exposure to abundant sunshine and unusually pure air. (Copyright ©Leon H. Abdalian; courtesy of Boston Public Library.)

The district was well known as a "place of residence for delicate people" and ranked high among the health resorts of New England. People prone to suffering from pulmonary, bronchial, and catarrhal diseases were said to do well here, and heart cases were frequently sent here from other areas where they were fairing poorly. (Copyright ©Leon H. Abdalian; courtesy of Boston Public Library.)

The world was a very different place in 1900, when the whole town gathered for skating and sleighing on Jamaica Pond, but patient stories from that time seem much in spirit of those of today. Andrew Jay Peters, mayor of Boston, shared his musings with Faulkner Hospital trustees: "When I was a patient here in 1908, this hospital just about filled the needs of the community." Cornelia Balch, daughter of Dr. Franklin Balch, recollected visiting patients with her father during the first years of the hospital. Another patient shared his story: "Dr. Arthur Nicholson Broughton picked Mother (and me) up in his sleigh and took us to Faulkner Hospital in a snowstorm and I was born the next morning." (Copyright ©Leon H. Abdalian; courtesy of Library of Congress LC-USZ62-98781 and LC-USZ62-88530.)

28

Three

THE EARLY YEARS

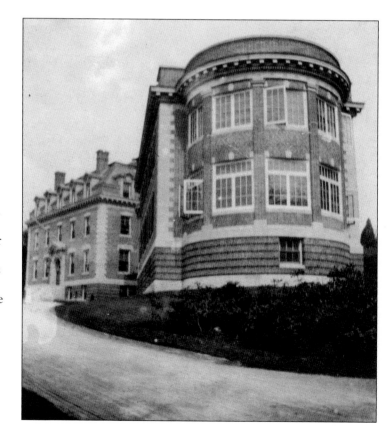

This is the first known photograph of Faulkner Hospital, taken in 1903. Faulkner Hospital's architect, Edward Fletcher Stevens of Kendall, Taylor, and Stevens, was known for his use of domestic imagery in hospitals. Stevens was a member of the American Institute of Architects (AIA), the Royal Architectural Institute of Canada (RAIC), and the American Hospital Association (AHA). The building was commenced in the summer of 1901 and completed within two years.

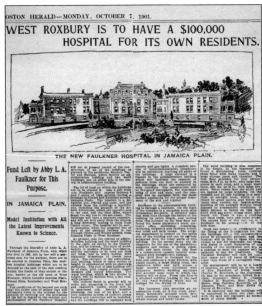

BOSTON HERALD—MONDAY, OCTOBER 7, 1901.

WEST ROXBURY IS TO HAVE A $100,000 HOSPITAL FOR ITS OWN RESIDENTS.

THE NEW FAULKNER HOSPITAL IN JAMAICA PLAIN.

Fund Left by Abby L. A. Faulkner for This Purpose.

IN JAMAICA PLAIN.

Model Institution with All the Latest Improvements Known to Science.

The Boston Herald ran this article in 1901. Charles H. Souther was the first president of the corporation. The bylaws and the rules of the trustees were completed in 1903. When the hospital first opened, patients had to provide a physician-signed application blank to the superintendent to be admitted. The original building contained 26 beds, six of which were free.

The architecture was a modern French Renaissance design, and the fireproof building was made of dark red brick laid in white mortar with elaborate cream terra-cotta. The hospital had a cast-iron widow's walk and dormer windows with exquisite decoration. The entrance to the administration building was ornamented with an elaborate cartouche. The roof was made of slate with a copper cornice, dormers, and trimmings. The interior finish was white ash and quartered oak.

Faulkner Hospital opened to public inspection in February 1903 and for patients in March 1903. The hospital was originally purported for all medical and surgical cases that were not contagious; however, the hospital's first patients included some with typhoid fever, bronchitis, and malaria. In fact, there was such a demand for beds during the typhoid epidemic of 1908 that the hospital asked patients to bring their own beds.

THE FAULKNER HOSPITAL

WILL BE OPEN FOR INSPECTION

ON

THURSDAY, FEBRUARY TWENTY-SIXTH

FROM

TWO TILL FIVE O'CLOCK

THE TRUSTEES CORDIALLY INVITE

YOU AND YOUR FRIENDS TO BE PRESENT

CENTRE AND ALLANDALE STREETS

JAMAICA PLAIN

Faulkner Hospital, Jamaica Plain, Mass.

The hospital produced this postcard in 1905. During the first 20 months there were 514 patients, with the hospital providing 3,043 hours of free treatment, performing 277 operations, and welcoming 23 newborns. Faulkner Hospital tracked occupations of its patients in the early days, which included blacksmiths, icemen, lamplighters, charwomen, and a maker of mathematical instruments.

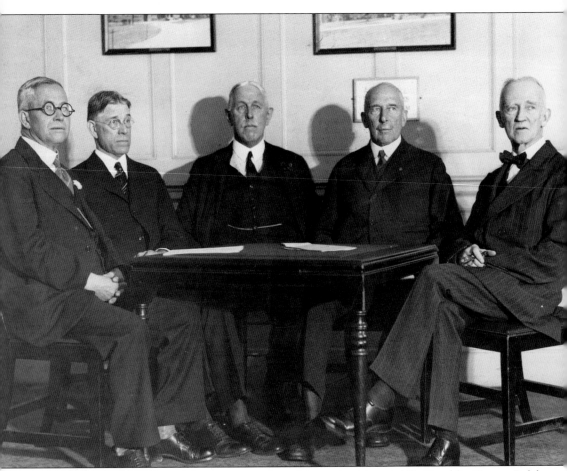

Dr. Henry Jackson (far right) was appointed as advisory physician and Dr. Franklin Greene Balch (second to right) as advisory surgeon. Dr. Balch, born in Jamaica Plain, had been an "interne" at the Massachusetts General Hospital. Four physicians from Jamaica Plain completed the medical staff: Dr. Henry W. Broughton, Dr. Arthur P. Perry, Dr. J. C. Stedman, and Dr. John H. S. Leard (far left). Dr. Arthur Nicholson Broughton (center) was the assistant and substitute for Dr. Balch. The superintendent was Laura Coleman, and L. M. Coleman was her assistant. The first trustees were Charles H. Souther, chairman; Charles P. Bowditch; Alfred Bowditch, treasurer; Henry Bainbridge Chapin; Emily Groom Denny, secretary; Ellen C. Morse; and Cora Bowditch. All the board members were from Jamaica Plain except for Emily Denny, who lived in Brookline. Shown here in 1932 are, from left to right, Dr. Leard, Dr. William Howell, Dr. Arthur Broughton, Dr. Balch, and Dr. Jackson.

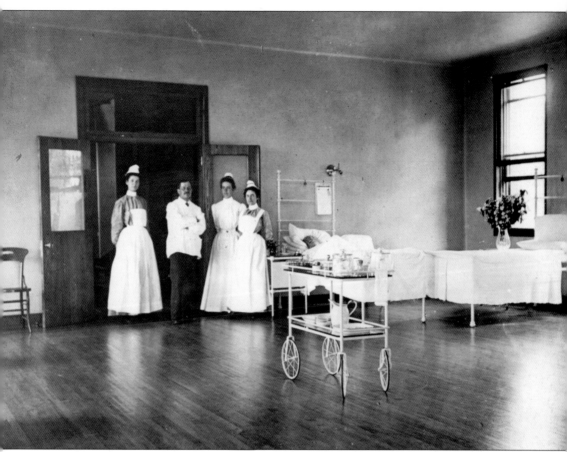

Any physician who was a member of the Massachusetts Medical Society or Massachusetts Homeopathic Society and a resident of the Old Town of West Roxbury could bring a patient to the hospital. Patients were admitted by the superintendent and could not remain after recovering from anesthesia. Private patients who were residents of West Roxbury could employ any physician who was a member of the Massachusetts Medical Society or Massachusetts Homeopathic Society, subject to approval of at least two trustees. The surgical service was under the charge of a surgeon appointed by the trustees. The medical service was under the charge of four residents of the Old Town of West Roxbury, who were also appointed by the trustees. In addition, the trustees appointed an advisory physician. This photograph from 1904 shows Dr. John H. S. Leard in one of the first wards. (Courtesy of Nocca Studios.)

THE NEW FAULKNER HOSPITAL IS OPENED FOR AN INSPECTION BY INVITED GUESTS.

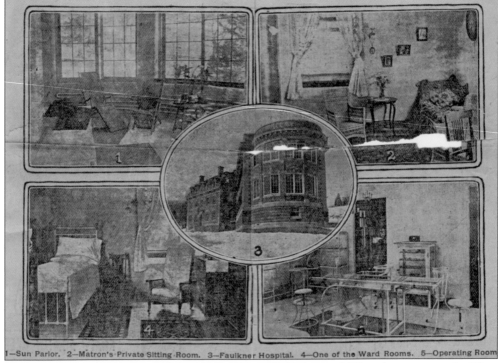

1—Sun Parlor. 2—Matron's Private Sitting Room. 3—Faulkner Hospital. 4—One of the Ward Rooms. 5—Operating Room

The *Boston Herald* ran this article in 1903 to describe the hospital. The administration building contained an office, parlor, and bedroom for the superintendent; reception, operating, etherizing, sterilizing, and recovery rooms; and a solarium. The second floor housed the nurses' quarters, dining room, kitchen, laundry, and servants quarters. A wing housed two open wards, eight private rooms, and a sunroom. The basement contained the examination room, pharmacy, laboratory, and storerooms.

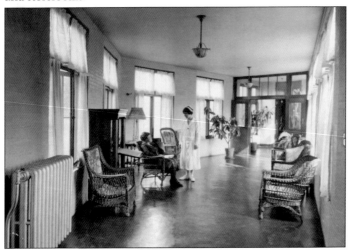

The *Roslindale News* hailed the opening of the hospital with this quote, "The surroundings are picturesque, rural, but not wild, quiet and restful." One of the hospital's early patients exclaimed, "I have had a lovely time. All the nurses are so kind and cheery, and everything is done in the best way. But it's because I'm in a wonderful hospital—the finest anywhere around here!"

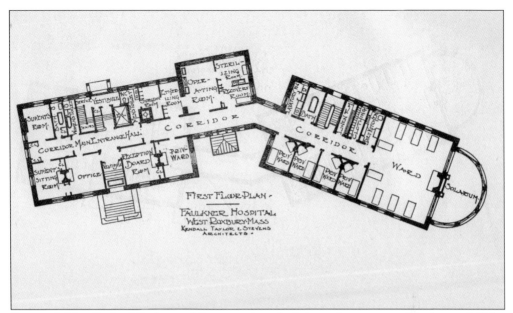

Pettigrew's New England Professional Directory described the early practices of the hospital: "The charges for private rooms shall be $3 to $5 a day, but where there are two beds in the room the charge shall be $15 a week. Ward beds for residents of old West Roxbury $10.50 a week, and for non-residents $12.25 a week, which is the minimum price."

The *Quarterly of the Harvard Medical Alumni Association* reported, "The hospital is most complete, with every modern convenience for the care of surgical and medical cases. The hospital is fully equipped; and no expense has been spared to secure the latest and most approved designs in arrangement and in appliances, so that, it may justly be considered the best in this part of the country at least." (Photograph by Maclardi.)

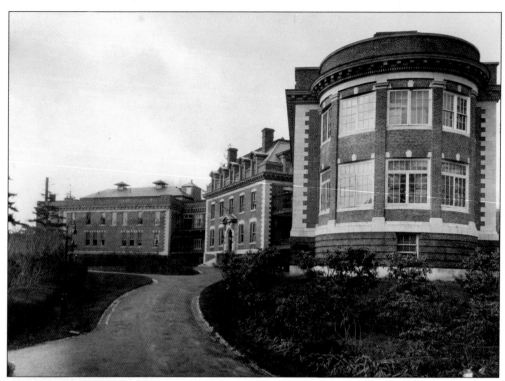

These photographs show the hospital in 1917 and Dr. Nelson Curtis, board chairman, in 1919. The staff was quite busy during the first two decades. The hospital's first superintendent, Laura Coleman, was cited for her heroic assistance after a railroad disaster in Epernon, France, in 1906. Faulkner nurses cared for 47 patients during the typhoid epidemic of 1908. Faulkner Hospital treated 440 patients in 1911, and 439 patients received a total of 6,921 days of treatment in 1912. In 1917, Faulkner Hospital nurses responded to the Halifax Disaster, when the city of Halifax was devastated by the huge explosion of a French cargo ship. During the influenza epidemic of 1918, nurses volunteered nobly to care for afflicted patients, both at Faulkner Hospital and other institutions. Nurses served both with the American and British Expeditionary Forces in France during the First World War.

Four

THE SCHOOL OF NURSING

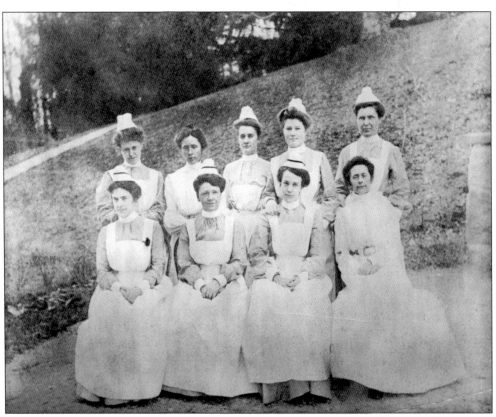

The Faulkner Hospital Training School for Nurses opened to nine pupils in March 1903 (on the day the hospital opened) under the direction of the superintendent, Laura Coleman. The superintendent also directed the entire hospital. The first graduating class in 1905, pictured here, boasted six graduates: Gertrude Lyon, Josephine Sennott, Anna Berford, Helen MacLarren, Margaret Foote, and Helen McCarthy, who became the new assistant superintendent.

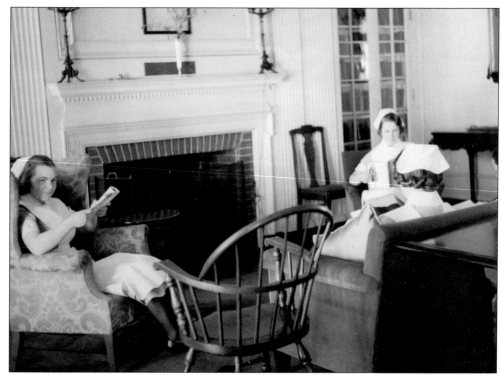

Applicants of the training school had to be 21- to 35-year-old unmarried women, pass examinations in English and arithmetic, and provide physician's certificates. It was recommended that a student visit the school to apply, accompanied by her mother. Early applicants were not required to be high school graduates; however, in 1928, admission standards were raised, with applicants required to show preparation in English, history, mathematics, chemistry, and language.

This photograph shows the nurses' residence in 1916. The first students were paid $9–$12 per month after a probationary period. They received instruction in cooking, hospital housekeeping, care of the sick, emergency management, massage, medicine administration, and period-specific theories, such as practical methods of supplying fresh air. A class on posture was added to the curriculum in 1922. (Photograph by Armstrong Photo Company.)

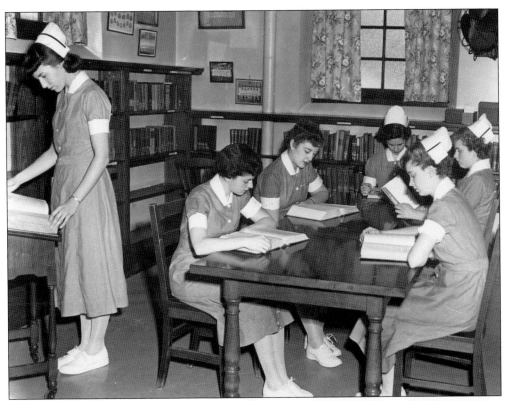

The early nursing students had long hours: 7:00 a.m. to 8:00 p.m. for day nurses and 8:00 p.m. to 7:00 a.m. for night nurses. Nurses on night duty were required to sleep between 9:00 a.m. and 4:00 p.m. The dress code included three gingham dresses and commonsense boots with rubber heels. The school opened as a two-year program, expanding to a three-year program in 1904. A housemother was hired in 1920. (Photography by Signal Photos.)

In the mid-1920s, the training school changed its name to the School of Nursing. The school was a tremendous asset to the community and the world. During World War II, the School of Nursing participated in the Federal Nurse Training Program, and students joined the United States Cadet Nurse Corps. Local ways the nurses made a difference included conducting blood pressure screenings and exercise classes. (Photograph by Alfred Brown.)

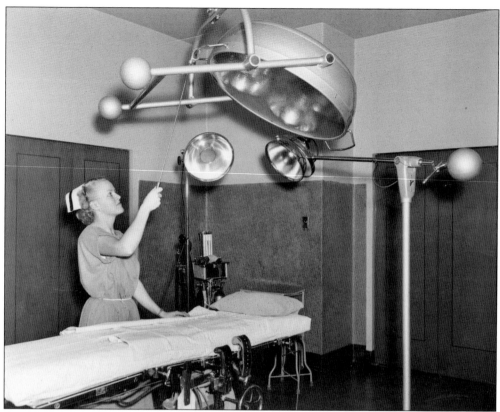

An education at the Faulkner Hospital School of Nursing prepared students for successful, productive, and fruitful careers in whatever branch of nursing they chose. Reports came from doctors outside of the district of West Roxbury, praising the work of many of the Faulkner Hospital graduates and commending the training provided at the school. (Photograph by Harold Orne.)

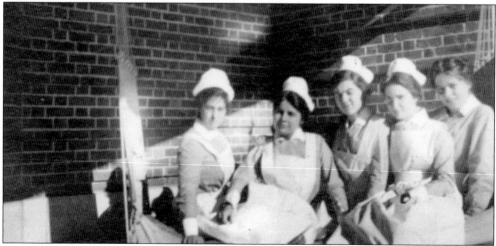

One of the earliest classes relaxes here in a hammock. Student activities included sleigh rides, a glee club, Christmas tree parties, New Year's Eve dances, and a bowling team. There was a recreation field for the students, complete with a tennis court. The nurses celebrated its opening with an afternoon tea.

One of the many benefits to the nursing students was on-campus housing. A nurses' home was designed by Wheelright, Haven, and Hoyt in 1913 with accommodations for 23 nurses. The home boasted a spacious outdoor porch with a broad view of the Blue Hills and offered nurses the opportunity to enjoy the refreshment of sleeping in the open air. The living room was partially furnished with furniture from the Faulkner's home. The home also contained a library, lecture room, and kitchen laboratory. A concrete subway connected the nurses' home to the administration building with steam piping to protect the students from the winter cold. This home was outgrown, and a larger, new nurses' home opened in 1926. The classrooms were on the first floor and in the basement, which also housed faculty offices. This building became a residence apartment house with a fitness center for employees after the School of Nursing closed.

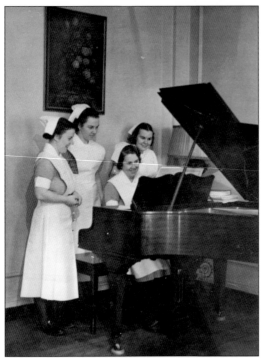

The establishment of Faulkner Hospital drew waves of bounteousness from its founders, supporters, and patients. Denizens of flowers, reading materials, and even medical equipment were donated. The hospital was awash in Easter lilies, rhododendrons, and carnations bestowed by grateful supporters. Dr. Faulkner himself donated a grand piano in 1905. Supporters rewarded the hardworking staff and students with donations of concert tickets and ice cream and cake for the nurses.

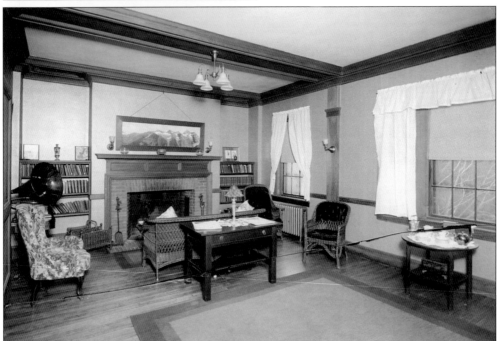

Like medical students, the nursing students had rotations. These rotations occurred during their freshman and junior years. What made it especially interesting was that the students lived in different on-campus dorms while completing their rotations. For example, during a pediatric rotation, students would live in dorms at the children's hospital. This 1916 photograph shows the living room in the first Faulkner Hospital nurses' home.

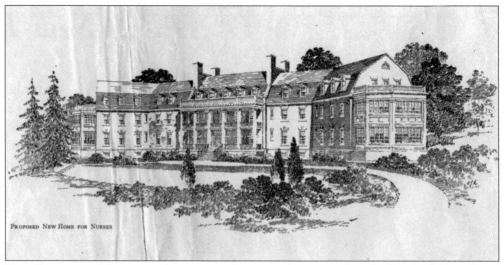

PROPOSED NEW HOME FOR NURSES

This illustration of the proposed new nurses' home was drawn in 1923. The New York State Board of Registration of Nurses reported in 1931, "It is evident that those in charge of the School aim for the highest nursing standards both for the ultimate good of the patient and the education of the student."

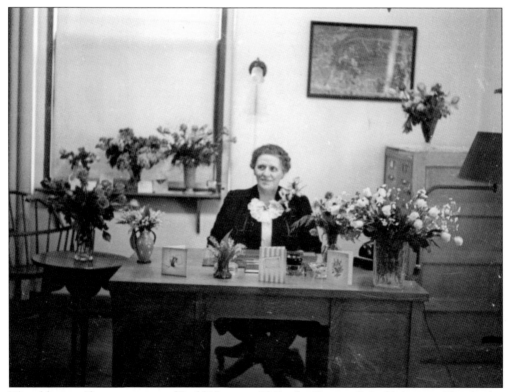

The old nurses' home was named Ladd House in 1949, after Francis C. Ladd (pictured here), who was superintendent during 1920–1945. A graduate of the Massachusetts General Hospital, Ladd taught in Albany and served as assistant superintendent of Cambridge Hospital. Ladd House accommodated the nursing offices, graduate nurses, and x-ray and laboratory technicians.

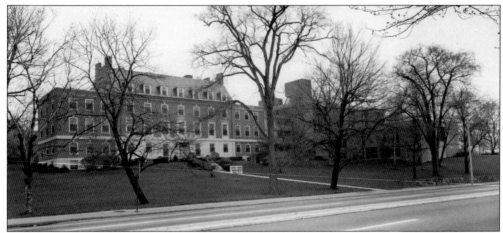

The nurses' home was once again renamed as the Chapin House, after board member Henry B. Chapin. Chapin House was like a real home. Graduate Mary Hourihan remembers it as a stately building with elegant touches like Oriental carpets, crown molding, built-in china cabinets, and comfortable leather sofas and armchairs. Housemothers were like second mothers to the nursing students.

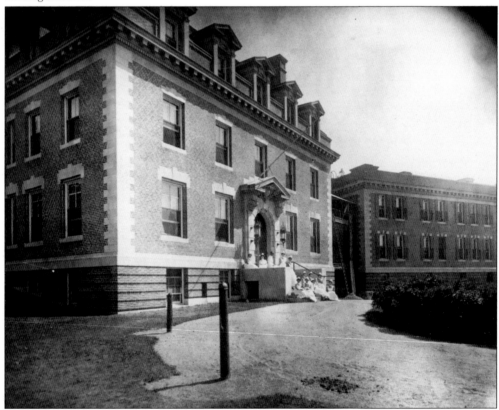

After the School of Nursing closed, the dormitories were used to house the Breast Centre, Faulkner/Sagoff Centre, Dialysis Clinic, Inc. (DCI), and administrative offices. The rooms have the same brick interior walls that were used to decorate the dorms. Each reception center in Belkin House used to be a nursing student lounge. This photograph shows the first nurses' home from 1908.

Class photographs and yearbooks from the school reflect the spirit of the times. This photograph is from the 1960s. The 1971 yearbook, titled *Us*, included quotes like, "Live for the moment, man," and "Open your heart and let the sunshine in." The 1976 yearbook was called *Yesterday* and included photographs of students donning peasant blouses and bell bottoms. Quotes bring back memories with phrases such as "color my world" and "love bug."

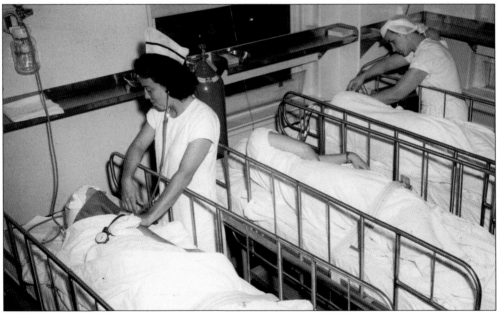

The School of Nursing received full accreditation from the National League of Nursing Education in 1941. In fact, out of 1,100 nursing schools in the country, Faulkner was one of only 209 to receive full accreditation in 1954. The school was also accredited by the Massachusetts Board of Engineers in Nursing. (Courtesy of Fay Foto.)

Coinciding with the Women's Liberation Movement, the School of Nursing updated its policy in 1962 to allow students to marry. However, permission would only be granted upon the student meeting "in conference with her parents or guardian with the Director of the School." In 1970, the first two male students entered the Faulkner Hospital School of Nursing. (Courtesy of Fay Foto.)

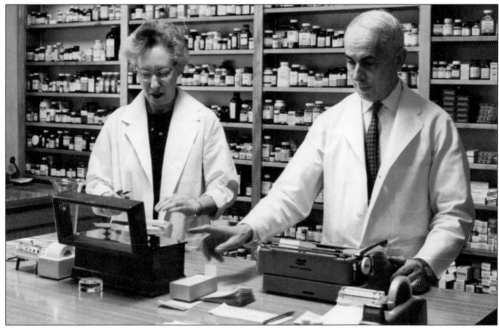

Mimi Iantosca was hired in 1967 to teach chemistry and microbiology. She eventually expanded the program to include mathematics. At the time, nurses prepared patient medications, which had not been premeasured. The class assured that the students were comfortable with critical concepts in medication measurement and accuracy. (Photograph by Dinin.)

The student uniforms have changed dramatically through the years. Prior to 1967, students wore stark white aprons over dark uniforms with black stockings and black shoes. After that, pale blue thinly striped uniforms with white collars and cuffs were worn. The female students were never allowed to wear pants. In the 1970s, the white shoes the nursing students wore were affectionately called "clinics." (Photograph by Robert Holland.)

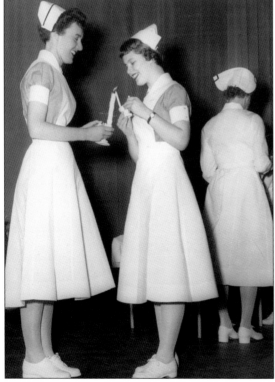

While many things changed at the nursing school, one item remained pretty much the same—the nursing cap. Freshman wore plain white caps. Second year students had a black stripe sewn on each side, and the seniors' caps were adorned with a full, but thinner, black stripe all the way around. The Capping Ceremony was held at the end of each freshman year.

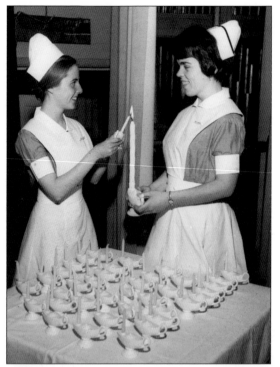

Graduate Mary Hourihan remembers her cap distinctly. Caps were made with thick cloth that had to be starched and shaped. It took Mary about three hours to fashion her cap around a lit bulb. "Once you had that cap, you never wanted to lose it," said Mary, "because you never wanted to have to go through that process again to make another one!" (Courtesy of Fay Foto.)

Other School of Nursing traditions involved presenting graduates with long-stemmed red roses, lighting the Florence Nightingale Lamp at capping, and a school ring emblazoned with the Faulkner seal. Nurses could wear their treasured white uniforms for the first time as new graduates. Graduates also received a school pin emblazoned with red, blue, and gold and a flower with F and H in the center. (Courtesy of Fay Foto.)

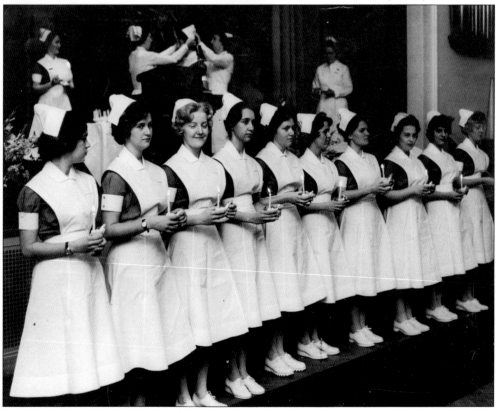

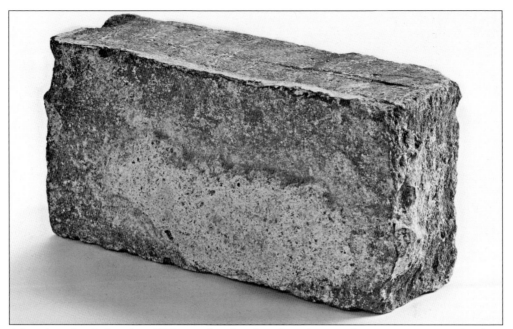

After the school closed in 1978, people who played a role in its history were given a brick to remember it by. Mary Martin still has her original brick (pictured) displayed in her living room. Dolly Marmol used her brick to line her garden, which she likes to look at because, as she says, "It reminds me of the Faulkner." (Courtesy of Mainframe Photographics.)

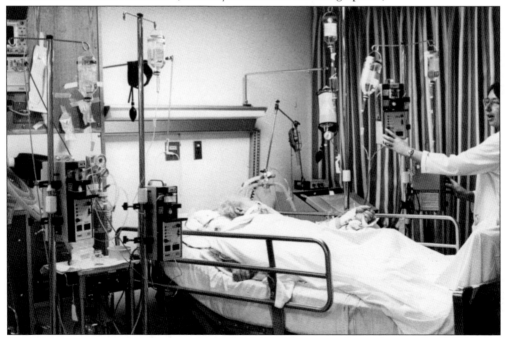

"Faulkner is a community where employees care about patients and care about each other," stated Professor Iantosca. "Each group working together has a sense of team—we work together!" Mimi has been inspired by the good work that Faulkner people do and wants to invest her time here because the people who work there are worth it according to her.

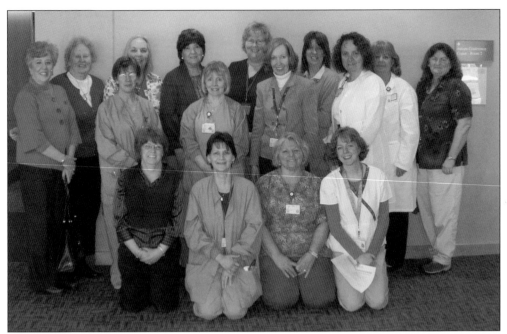

Seventeen graduates of Faulkner Hospital School of Nursing are currently employed at the hospital: Karen McGrath, Thelma Sacco, Pat McCue, Bonie Fallon, Peggy Thomasini, Linda Luce, Nancy Harrington, Loraine Shannon, Mary Martin, Pat Mulhern, Jean Crimmins, Pat Marinelli, Phyllis Cotter, Betsy Kasper, Maria Nicolazzo, Mary Hourihan, and Pat Buckley. "The Faulkner Hospital School of Nursing was a truly fabulous school," exclaimed Mary Hourihan, class of 1977. (Courtesy of Phillip Malleson.)

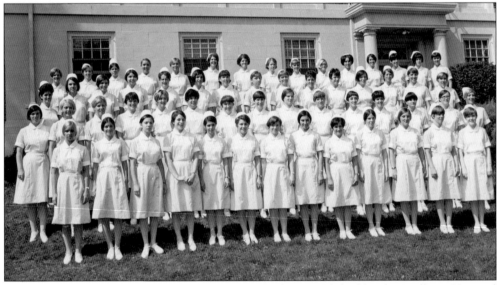

The legacy lives on. Funded by a sustaining scholarship established by the Faulkner Hospital School of Nursing Alumnae Association, the Massachusetts Nurses Foundation offers Faulkner Hospital School of Nursing Alumnae Memorial Scholarships. These awards are bestowed annually with first preference given to applicants who are lineal descendants of alumnae of the Faulkner Hospital School of Nursing. This photograph shows the class of 1970.

Five

LEADERS IN MEDICINE
AND RESEARCH

The earliest physicians were members of the Massachusetts Medical Society or Homeopathic Medical Society. Faulkner was the first private hospital in the country with medical students and residents. "From our beginnings, we were a teaching hospital," stated Dr. Andrew Huvos. "A tribute to our teaching is that many of our residents stayed on our staff." Pictured here is Dr. John Leard, one of the hospital's first physicians. (Photograph by Horner Studio.)

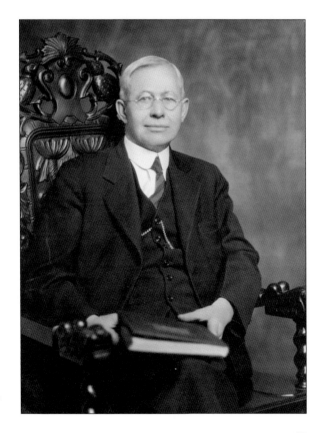

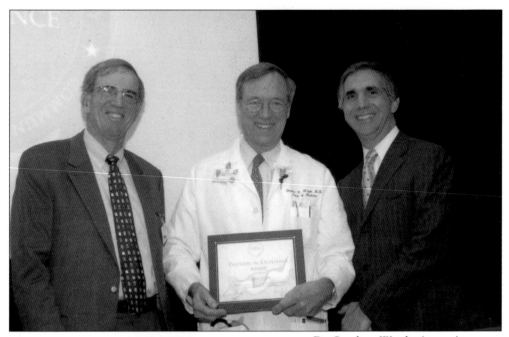

Dr. Stephen Wright (center), coordinator of Medical Student Education, has served as clinical professor at Tufts Medical School and lecturer at Harvard Medical School and became Faulkner Hospital's first chief medical officer. "I see medical education as a means by which the hospital can continue to deliver the highest quality of care and to replenish the faculty by adding talented young people to the Department of Medicine," declared Dr. Wright.

In what was heralded as an "experiment," a fourth-year Harvard Medical School student lived at the hospital in 1918 to attend to the routine laboratory work. This experiment proved so desirable that it became a permanent position, and the next fourth-year student filled the position of house officer. (Photograph by Dinin.)

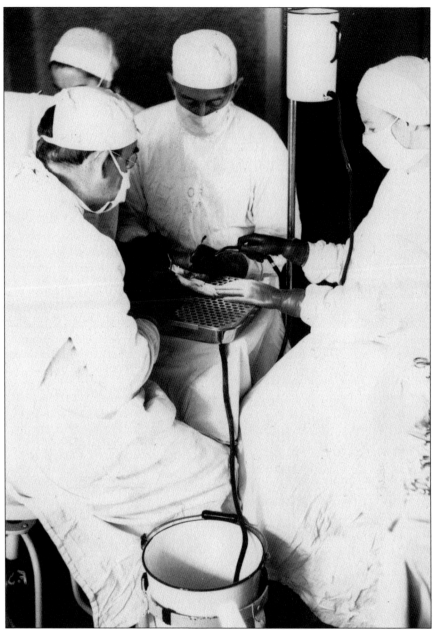

From early on, Faulkner Hospital cases were published in the clinical literature. Two cases were described in *Annals of Medical Practice* in 1906. The *Boston Medical and Surgical Journal* described a case concerning a 51-year-old housewife with girdle pains that required much Codeia for relief and a case of a 52-year-old salesman complaining of a stomachache following a hearty dinner of steamed clams. Case records have also appeared in the *Journal of the American Medical Association* (JAMA), including the case of passage of a corsage pin from a boy's stomach. The *New England Journal of Medicine* held a weekly feature, "Case Records of the Faulkner Hospital," beginning in 1937. Cases were taken from clinical meetings at Faulkner Hospital in the form of cliniopathological conferences with paper discussions of cases not seen by the discusser. They included difficult-to-diagnose cases such as coronary occlusion and De Quervain's Disease.

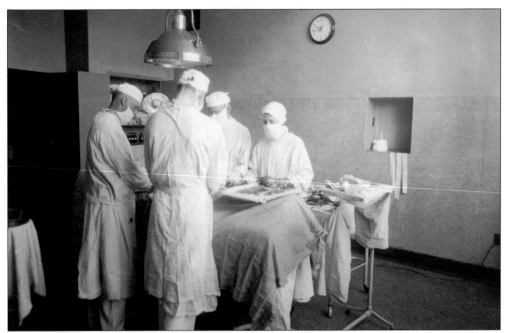

The earliest paper by Faulkner Hospital surgical staff was published in the *Journal of Nervous and Mental Disease* in 1906: "A Contribution to the Study of Cerebellar Tumors and their Treatment." This paper was read at a meeting of the American Neurological Association. It described a case where a tumor was found and removed with "marked benefit to the patient."

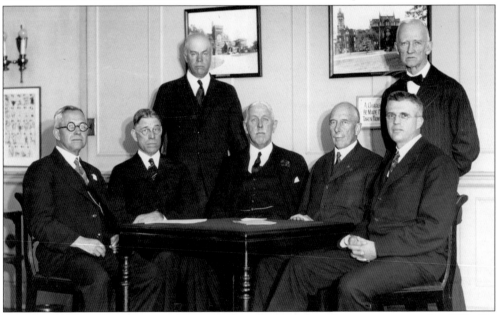

The first house staff was appointed in 1918. An official medical department opened in 1930. Dr. Channing Frothingham became the first designated physician to Faulkner Hospital in 1932, the year this photograph of the medical staff was taken. The hospital's first official designation came in 1934, when Faulkner Hospital was designated by the State Department of Health as a center for the typing and distribution of pneumonia serum.

In October 1934, Faulkner Hospital hosted a special program for the American College of Surgeons to introduce them to the work of the clinic along the lines of bone and joint work, especially the traumatic and reconstructive type. Faulkner Hospital surgeons performed operations for the honored guests, and there were x-ray and pathological exhibits and lectures on topics like hand surgery and surgical pathology. (Photograph by Dorothy Jarvis.)

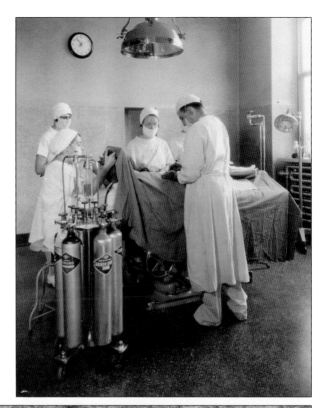

Faulkner Hospital physicians had many roles. Dr. Henry Broughton taught obstetrics, Dr. Balch lectured on fractures, and Dr. Arthur Perry instructed on poisons and their antidotes. During World War I, Dr. Franklin Balch, Dr. Kenneth Dole, Dr. Robert B. Osgood, and Dr. E. Lawrence Oliver traveled to Europe to serve the country. Dr. Arthur Broughton made history by signing HR5033 to end the manufacture and sale of liquor for medicinal purposes. (Courtesy of Forest Hills Cemetery.)

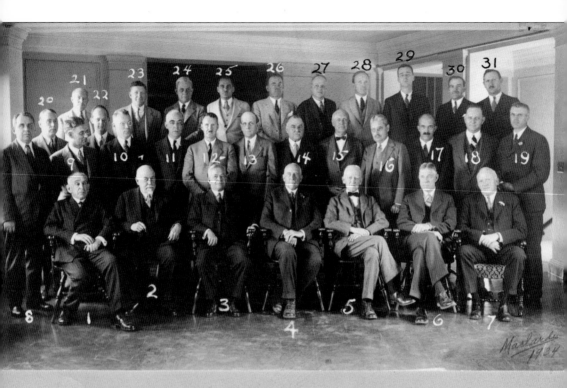

Elliot G. Brackett, M.D.
Frederic J. Cotton, M.D.
John S. H. Leard, M.D.
Franklin G. Balch, M.D.
Henry Jackson, M.D.
William W. Howell, M.D.
James R. Torbert, M.D.
Henry C. Marble, M.D.

9-Sidney L. Morrison, M.D.
10-Horace K. Sowles, M.D.
11-Burton E. Hamilton, M.D.
12-Calvin B. Faunce, M.D.
13-Arthur A. Cushing, M.D.
14-E. Lawrence Oliver, M.D.
15-Channing Frothingham, M.D.
16-Raymond S. Titus, M.D.

17-Lloyd T. Brown, M.D.
18-J. Stewart Rooney, M.D.
19-Edward L. Young, Jr., M.D.
20-Leon E. White, Jr., M.D.
21-Josiah E. Quincy, M.D.
22-F. William Marlow, Jr., M.D.
23-Frank E. Barton, M.D.
24-D. J. Bristol, M.D.

25-G. Bernard Fred
26-Gerald L. Doher
27-Howard B. Jackso
28-Franklin G. Balch,
29-Sidney C. Widdin
30-Henry M. Emmon
31-Harry C. Solom

This photograph shows the medical staff in 1934. The 1930s heralded the enlargement of medical services, with the introduction of physiotherapy, neurology, bronchoscopy, anesthesia, occupational therapy, and a tumor clinic as well as a laboratory technical course and a dietician. Advances at Faulkner Hospital during the 1930s included insulating patches and absorbable sutures made from fetal membranes and pioneering research in the area of successful delivery of babies to diabetic mothers. The hospital's teaching service was in full force by this time. House officers began rotations through the pathology service. "Internes" (the spelling used at the time) were given care of a minimum of 15 patients in each of the medical, surgical, and obstetrical departments. Patients cared for by the interns were called house patients. There were also "externes" who were medical students who worked in the hospital for a few months but did not live on campus. (Photograph by Maclardi.)

World War II overshadowed the 1940s, when blackout curtains were added to the windows and a surgical ward closed due to staff shortage. In 1942, ninety-four staff members were serving in the military. A blood bank opened in 1943, and Faulkner Hospital began to make its own intravenous solutions. It was originally staffed by nurses, students, and externes. This photograph shows the hospital in 1945. (Photograph by Harold Orne.)

In 1945, trustees voted that the professional staff would retire at the completion of their 61st year. In 1946, staff was reorganized in accordance with the Standards of a General Hospital in the Metropolitan Area. The medical staff consisted of officers; executive, pharmacy, credentials, and medical records committees; and chiefs of service for medicine, surgery, obstetrics/gynecology, and laboratory. Staff was organized into consulting, active, and courtesy groups. (Photograph by Harold Orne.)

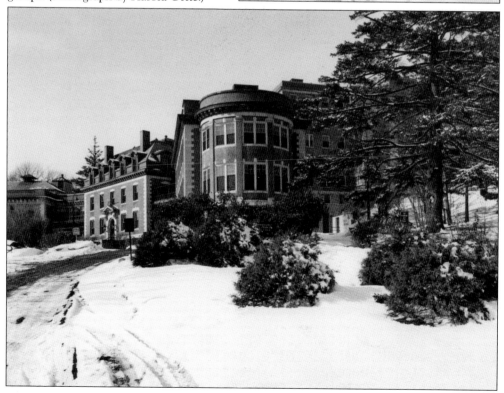

In 1947, Faulkner Hospital began a residency program in internal medicine and a training school for x-ray technicians. Following that was a residency training program in radiology. When this photograph was taken in 1948, Chief of Medicine Dr. James Halsted established a policy that all patients would be expected to participate in the education of physicians in training. The hospital has also initiated fellowship programs. (Photograph by Harold Orne.)

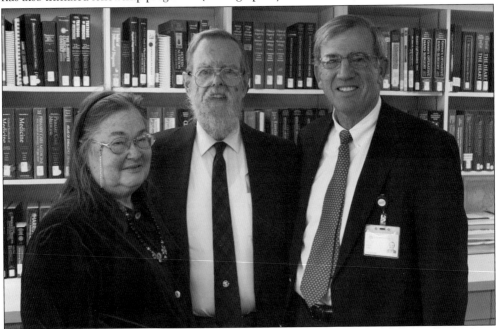

What was it like to be a student at Faulkner Hospital during the 1950s? Dr. Jeanne Arnold (left) remembers those days well. She and Dr. Peter Jeffries (center) visited Faulkner Hospital in 2009 and met president David Trull (right). The externs spent their days studying and then worked alongside student nurses. Responsibilities included examining patients, drawing blood, and starting IVs. They received stipends of $15 to $30 per month.

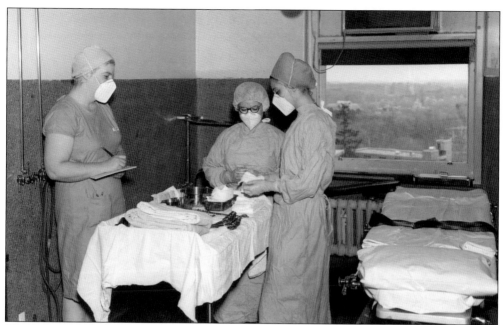

The two photographs show the array of surgical instrumentation used in 1966. The 1960s were a time of growth at Faulkner Hospital. In 1961, the Faulkner staff started the Headache Study Group, which developed into the world-renowned John R. Graham Headache Centre. The Psychiatric Service and Intensive Care Unit were launched in 1966 and the Social Services and Nuclear Medicine Departments in 1967. The Concentrated Care Center, Ambulatory Diagnostic Clinic, Stoma Therapy Service, and Pulmonary Services Department were added in 1969. With growth came change, and in 1967, Faulkner Hospital discharged its last obstetrical patient and discontinued its maternity service of nearly seven decades. A banquet was held to honor all those who built Faulkner Hospital's lauded obstetrical service. (Both, courtesy of Fay Foto.)

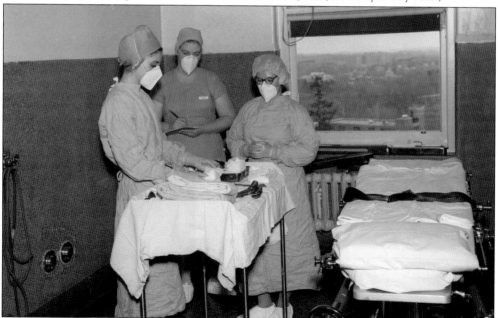

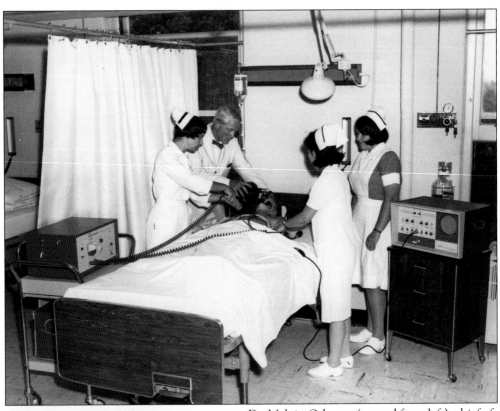

Dr. Melvin Osborne (second from left), chief of surgery, oversaw the surgical residency program in the 1960s–1970s. Residents were trained from Deaconess Hospital and Boston City Hospital through the Harvard Fifth Surgical Service from 1962 through the 1980s. In the 1990s, Tufts surgical residents rotated from the New England Medical Center. Many of the graduates of this program are now chiefs of surgery at various institutions. (Courtesy of Fay Foto.)

A portrait of the operating room staff from the 1960s provided a glimpse into the past as OR technicians relaxed during a break in their busy day. In 1966, a two-car Boston-bound New Haven Buddliner railroad commuter train was derailed. Within minutes, victims were treated in five disaster treatment areas—triage, first aid, operating room, burn and shock, and emergency holding—and all 26 patients were treated within three hours.

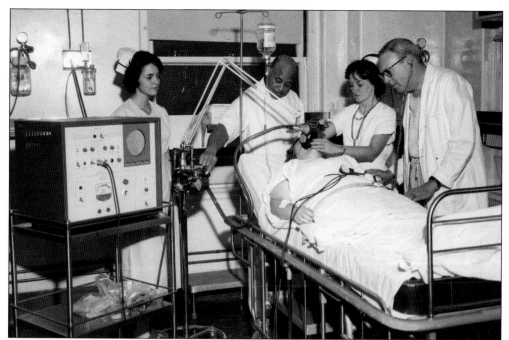

Faulkner Hospital offered many educational opportunities during the 1960s, including residency programs in medicine, surgery, obstetrics, and radiology; x-ray technician and medical technology training; and a nursing school. In the late 1960s, Faulkner Hospital began a psychiatry residency program, a social work training program, and a physical therapy training program. (Courtesy of Fay Foto.)

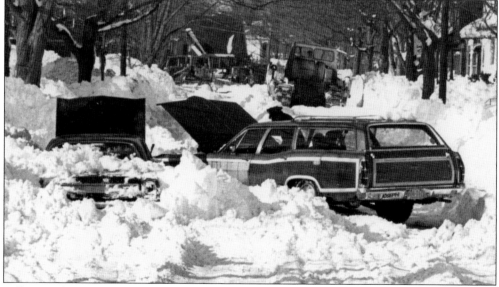

Following the Blizzard of 1978, the first two children born in Boston were delivered at Faulkner Hospital. It snowed for two days, each time over 20 inches with hurricane winds. The National Guard did not allow drivers on the roads for a few days. Volunteers tirelessly put together "stormy weather kits" with three-day provisions for patients going home after the blizzard. (Courtesy of U.S. Army Corps of Engineers.)

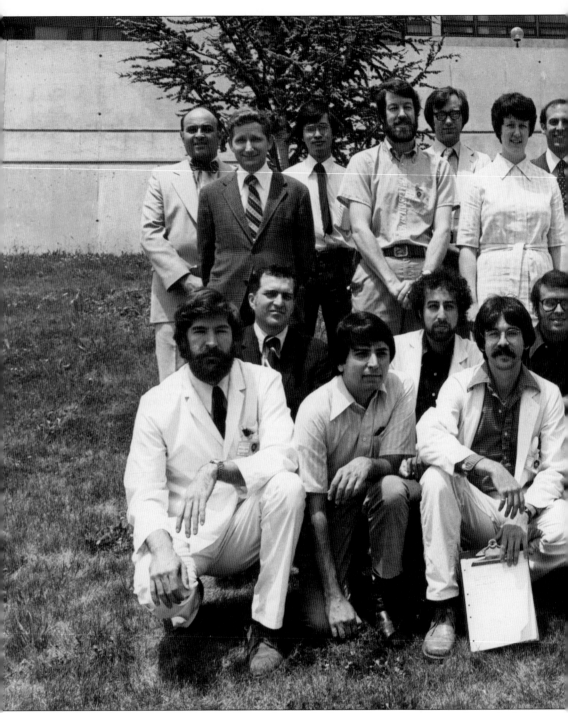

Before the 1970s, there were few subspecialties at Faulkner Hospital, and consultants had to be brought in. That changed as the hospital began to build new subspecialty programs. Between 1970 and 1990, the Department of Medicine, under the leadership of Dr. Andrew Huvos, developed departmental divisional status for gastroenterology, hematology, oncology, infectious disease, nephrology, endocrinology and metabolism, cardiology, neurology, pulmonary disease, and

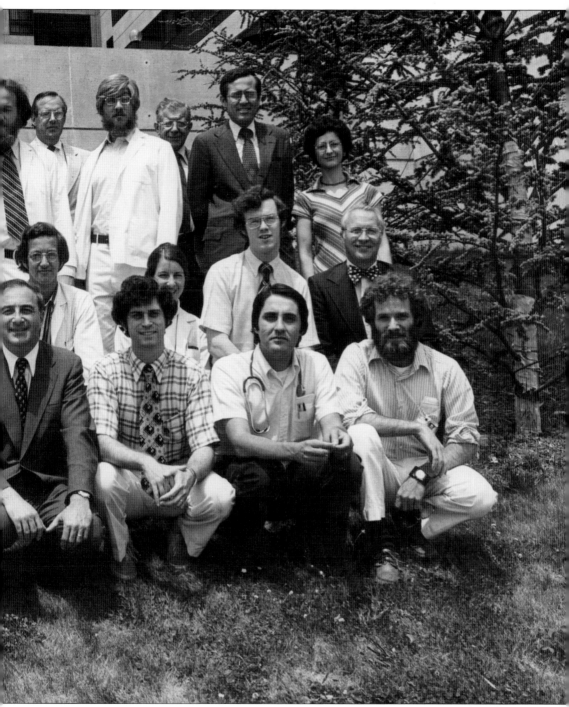

rheumatology services. The occupational therapy department; pediatric service; otolaryngology; nutrition clinic; ostomy clinic; ER follow-up clinic; ear, nose, and throat service; ophthalmology service; and Faulkner Anesthesia Associates also began in the 1970s. Many of the departments and services started out with solo practitioners, such as nephrology with Dr. David Cahan serving as both the chief of nephrology and the hospital's first full-time nephrologist.

The Audiology Service (pictured here), Day Surgery Program, Pre-operative Evaluation Clinic, Incontinence Clinic, Alcohol Detoxification Unit, Centre for Reproductive Health, Breast Centre, Eye Consultation Unit, Refractive MRI Unit, Eye Surgery Centre, Eyecare Laser Centre, and Dental Service were all expanded in the 1980s. The original three "Centres of Excellence" were designated during the 1980s: the Faulkner-Sagoff Centre, the John R. Graham Headache Centre, and the Faulkner Breast Centre.

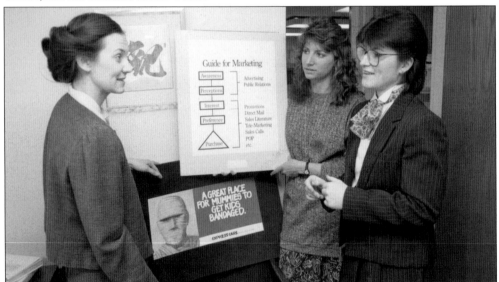

A walk-in clinic named Faulkner Express Care debuted in the 1980s, servicing almost 500 patients in a month. Express care soon expanded to Dedham, Hyde Park, Brookline, Roslindale, West Roxbury, Boston, Needham, Newton, Quincy, and Westwood with consultation services that included internal medicine, surgery, gynecology, neurology, cardiology, endocrinology, hematology, oncology, pulmonary medicine, urology, allergy, immunology, dentistry, dermatology, otolaryngology, gastroenterology, infectious disease, nephrology, ophthalmology, podiatry, psychiatry, rheumatology, vascular medicine, and orthopedics.

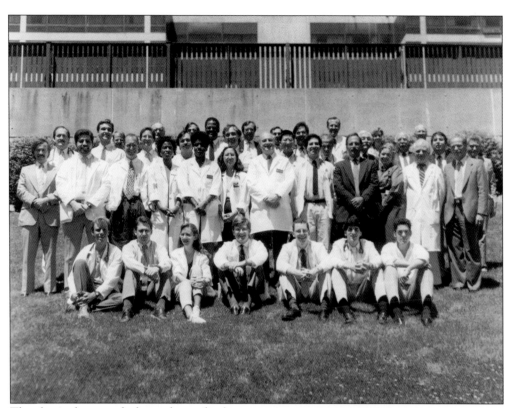

The above photograph shows the medical staff from 1990. Dr. James A. Warth (shown in the portrait at right and in the second row, far right above) discovered a new human red blood cell, an erythrocyte named a Sequestrocyte that was published in the peer-reviewed *Journal of Cell Science*. Dr. Amiel Cooper and Dr. Scott Shepard developed a novel polymerase chain reaction–based method to analyze expression of two genes in a single reaction. Faulkner Hospital was a site for a National Institutes of Health (NIH) research grant, which resulted in major contributions to the field toward the surgical and pharmacological approaches to patients with portal hypertension and variceal bleeding. This body of research continued for more than 20 years, resulting in articles in the literature published by Dr. Norman Grace, Dr. Stephen Wright, Dr. Daniel Matloff, Dr. Stephen Drewniak, and others at Faulkner Hospital.

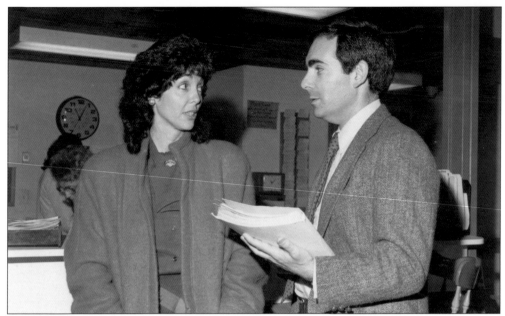

The first licensed unit of rejuvenated red cells ever transfused occurred at Faulkner Hospital under the auspices of Dr. Geoffrey Sherwood (pictured right, with Pres. Elaine Ullian) and the Faulkner Blood Bank. The process of rejuvenating outdated blood was developed by Boston scientists and was licensed by the American Red Cross Northeast Region. Medical technologist Dolly Marmol was the first technologist to cross-match rejuvenated blood.

Dr. Paul Bettencourt (pictured left, with a student) and Joseph Audette developed an original nasal continuous positive airway pressure device (CPAP) in 1982, which improved the quality of life for sleep apnea patients. In 1998, Dr. Bettencourt, Bruce Mattus, Rose Pachas, Bonnie Fallon, and Margaret Ferguson developed infection control and oral-care practices to reduce the rate of ventilator related pneumonia.

The Faulkner Hospital Pharmacy, shown in 1987, secured a new drug—penicillin—almost a year prior to its release for general use during the 1940s. The pharmacy also introduced vaccines such as Salk and Asian Influenza as they were discovered. Faulkner Hospital attracted worldwide interest in 1965 by sponsoring an international conference on drug side effects. For the first time staff reported research on connections between drugs and collagen disease.

The laboratory also contributed to medical advances as clinical chemist Dr. Mayo E. Brown introduced new techniques for measurement of specific gravity by body fluids and for the estimation of proteolytic enzymes in the blood. Dr. Brown was also awarded a research grant in 1963 from the NIH for investigation of the fibrinogen molecule.

The laboratory was awarded College of American Pathologists (CAP) laboratory accreditation in 1998. The blood bank was a recipient of a national accreditation by the American Association of Blood Banks (AABB) in 1996 and 2000 for it transfusion and tissue activities. Dolly Marmol, assistant supervisor of the blood bank, remembers the first surveys; the inspectors observed the staff in their daily activities and asked questions about their work.

The Faulkner-Sagoff Breast Imaging and Diagnostic Centre is world renowned. Dr. Norman L. Sadowsky was one of the earliest doctors to perform mammography and obtained one of the first dedicated mammography machines in the United States for Faulkner Hospital in 1971. Dr. Sadowsky described a major breakthrough in diagnostic x-ray testing, known as computerized axial tomography, and the first CAT Scanner was installed in 1979. He also pioneered same-day mammography results.

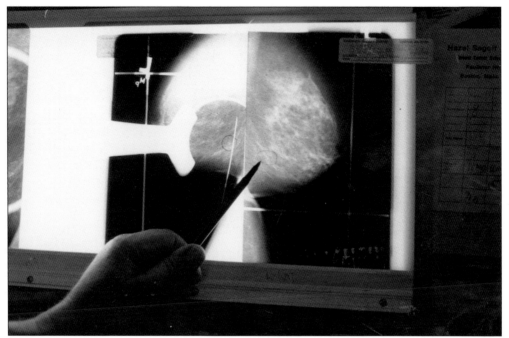

The Faulkner-Sagoff Centre was named after Hazel Sagoff, a well-known civic leader who died several years earlier of breast cancer. With support from Maurice Sagoff, Dr. James M. Faulkner (dean of Boston University Medical School and a highly regarded internist in Boston), Mary Faulkner (his wife), Edna Stein (a family friend), and their families and friends, the center expanded its services, and the present facility was dedicated in 1985.

The John R. Graham Headache Centre was named for Dr. John Ruskin Graham. In 1950, Dr. Graham became chief of medicine at Faulkner Hospital, a post he held until 1974. He established the Headache Research Foundation and organized Headache Associates, which became a dedicated headache clinic in 1987. Dr. Graham (left) is pictured in 1976 with John Blanchard (president) and Dr. Norman Sadowsky. (Courtesy of Max Bermann.)

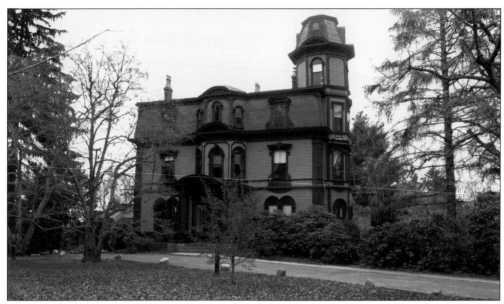

Adams House, the wing that houses the psychiatric service, was named for Seth Adams, a sugar merchant and printer who founded the Adams Nervine Hospital in 1882, a "curative institution for nervous, non-insane inhabitants." The original building (pictured here) sported Queen Anne design and a wood-frame, Colonial Revival director's residence. The Adams Nervine Hospital, designated as an official landmark by the Landmark Commission, closed in 1976. (Courtesy of James Woodward, Creative Commons.)

The Huvos Auditorium was named for Dr. Andrew Huvos, chief of medicine from 1974 to 1995, and professor emeritus of medicine at Tufts University School of Medicine. Dr. Huvos joined Faulkner Hospital as chief of the newly formed Service of Cardiology in July 1970 and assumed the post of chief of medicine in 1974. The auditorium was dedicated to Dr. Huvos in June 1995.

The Ramirez Cardiac Testing Center was named for Dr. Alberto Ramirez, Faulkner Hospital chief of cardiology, director of clinical cardiology at Brigham and Women's/Faulkner Hospital Cardiology, associate clinical professor of medicine at Tufts University School of Medicine, and assistant clinical professor of medicine at Harvard University Medical School. The Ramirez Cardiac Testing Center was established with funds donated by Arthur Gutierrez, Faulkner Hospital trustee and longtime supporter. The Gutierrez Medical Staff Lounge was named for another donation by Arthur Gutierrez in honor of Dr. Alberto Ramirez in 1996. Dr. Ramirez's research has included discoveries in acute myocardial infarction and congestive heart failure. (Courtesy of Alberto Ramirez.)

The Pariser Conference Room was named for Dr. Kenneth M. Pariser, chief of rheumatology, director of medical education, and associate professor of medicine at Tufts University School of Medicine. Dr. Pariser also served as president of the medical staff. The dedication of the room recognized donors Joseph and Thelma Linsey. Other donors contributed funds for the classroom, particularly Alfred and Karen Ross. The room provides space for education of residents and medical students. (Courtesy of Kenneth Pariser.)

The LeCompte Laboratory was named for Dr. Philip M. LeCompte, chief of pathology at Faulkner Hospital until 1974. He received international recognition for his research in diabetes and coauthored the textbook *The Pathology of Diabetes Mellitus*. Dr. LeCompte taught at both Yale and Tufts University Schools of Medicine. A portion of the laboratory had been named for Dr. Arthur A. Cushing in 1955, at the recommendation of Dr. LeCompte.

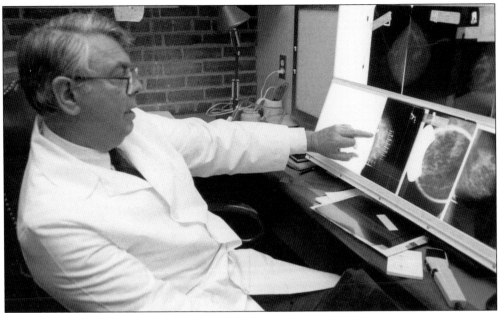

The Sadowsky Conference Room was named for Dr. Norman Leonard Sadowsky, chief of radiology emeritus and clinical professor of radiology at Tufts University and clinical instructor of radiology at Harvard University. Dr. Sadowsky developed a new technique for improved excision of nonpalpable breast lesions and made early forays into the area of speech recognition software for radiology reports using Kurzweil technology.

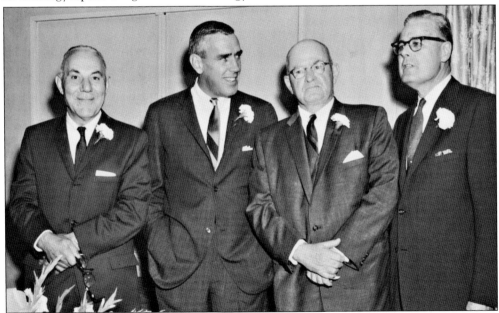

The Doherty Conference Room was named after Dr. Gerald L. Doherty, an orthopedic surgeon who worked at Faulkner Hospital between 1923 and 1953. There was also a Gerald L. Doherty Room in the old hospital, dedicated in 1963 (shown). The room was originally intended to be named for a patient, whose family requested that it be named instead in honor of her physician, Dr. Doherty.

The longtime medical staff enjoys fond memories of their early years. While many things may have changed since this photograph was taken in 1968, the sense of community and caring has not. "Faulkner Hospital was a small and quite intimate place when I came here. I used to know every intern, resident, and x-ray technician," recollected Dr. Max Bermann. "When I first came to the Faulkner, I was struck by how cordial and warm everybody was," exclaimed Dr. Andrew Huvos. "The community, dedication of the physicians and the commitment to teaching are what make Faulkner Hospital special," added Dr. Zeljko Freiberger. Pres. David J. Trull expressed the essence of the phrase "Faulkner Cares": "Faulkner is really about the quality of caring that our staff delivers to patients and our commitment to helping to educate a new generation of physicians and surgeons." (Photograph by Dinin.)

Six

FAULKNER HOSPITAL THROUGH THE AGES

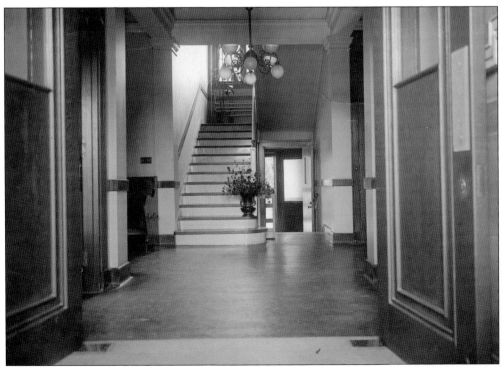

When visitors came to Faulkner Hospital in 1918, this was the welcoming view they saw upon entering the administration building. Patients could only be visited between 3:00 p.m. and 4:00 p.m. and no more than two visitors were allowed at one time. While visiting hours increased, children under 12 could visit only on Saturday afternoons throughout the 1920s, and precautions in the 1950s forbid children under 14 from visiting at all.

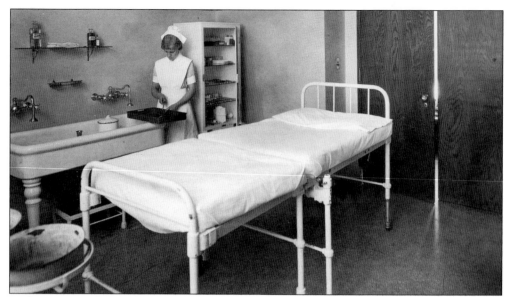

Faulkner Hospital opened as a model institution with all the latest improvements known to science. The state-of-the-art building opened with a complete system of steam heating and ventilation, electric and gas lighting, a system of intercommunicative telephones, and a large elevator. The maternity building, pictured here in 1917, featured splayed doorjambs, fireproof construction, nearly soundproof walls, separate heating, and even an electric elevator.

When the hospital first opened, only two maternity cases were allowed at a time. The original ward soon outgrew its space. The new maternity ward was designed to accommodate 22 patients, with two open wards and 14 private rooms. Two floors contained nurseries with toilet trays for each baby and warming closets for bedding and clothing. A small room was provided for isolating a baby in case of need.

The *Boston Herald* sent their "roving reporter" to Faulkner Hospital in 1929. The rover was in luck to observe the workings of the Faulkner Hospital nursery, many of the babies representing the second generation of their families to be born at Faulkner Hospital. He found that "the special nurses at Faulkner were very busy with their charges. Bathing, feeding and sleeping went on flawlessly."

In the 1940s, incubators for premature babies were a novelty. Faulkner Hospital built its own unit, constructed by staff engineers under the direction of an obstetrical nurse. The mobile unit provided temperature, oxygen, and humidity control. This baby received oxygen from an Armstrong incubator in 1948. (Photograph by Harold Orne.)

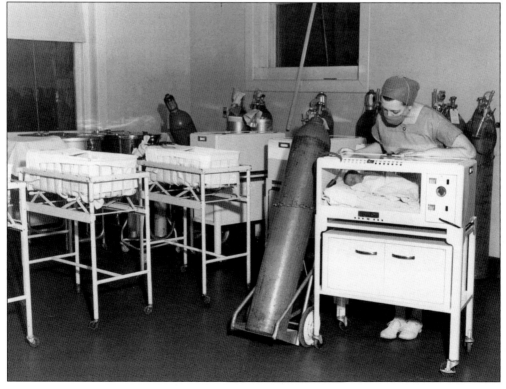

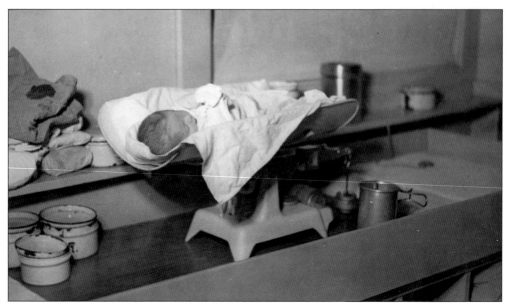

On October 31, 1967, Faulkner Hospital discharged its last obstetrical patient. The Division of Medical Care of the Massachusetts Department of Public Health recommended that the hospital close its obstetrical service. A banquet was held at the hospital to honor all those who built Faulkner Hospital's admirable and lauded obstetrical service.

Adult wards also changed through the years. In the 1920s, radios were permitted only with the consent of the superintendent. In the 1940s, patients were not allowed to use radios in semiprivate rooms or open wards unless they used earphones or Hushatones. Individual pillow coin radio service was introduced in the 1950s, and patients were allowed to bring a television set with permission from the director.

In 1928, facilities consisted of an administration building, medical building, service building, surgical building, maternity building, heating plant, and nurses' home. In the 1930s, the hospital was equipped with Telechron clocks, Monel metal hoppers, underground electrical circuits, an automatic ice-making machine, and a feature whereby soiled instruments were cleaned and pushed through a wicket to a clean instrument room. (Photograph by George Brayton.)

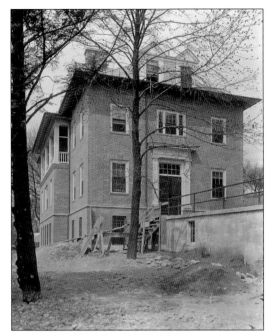

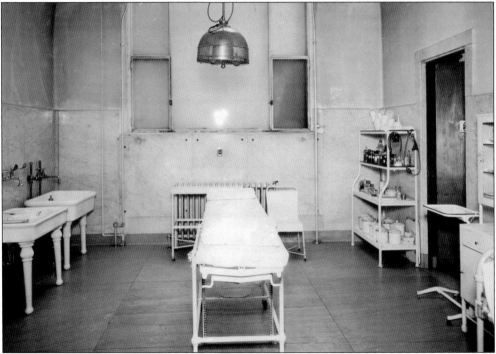

The hospital's new surgical wing was officially opened and dedicated in 1930 in the presence of Gov. Frank G. Allen and Mayor James Michael Curley. The wing included nose and throat operating rooms and a plaster room. The operating rooms were embellished with gray-green Terraza and equipped with built-in closets and sunken x-ray recesses. The new service wing included laboratories; cytosocopy and fluoroscopy departments; and electrocardiogram, x-ray, and metabolism rooms.

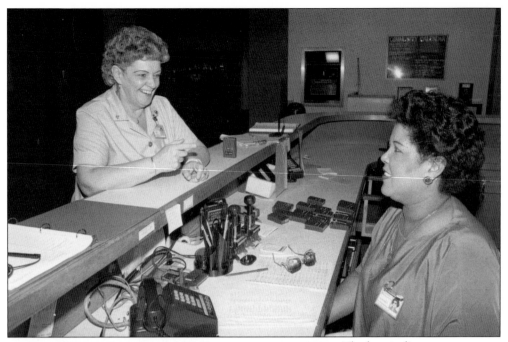

The hospital's present operating room is twice as large as most operating rooms in the United States. The surgery department planned many new initiatives and was forward thinking in the building process. This photograph shows operating room greeters and escorts in 1987. In the 1980s, there were even two operating rooms for the eyes, one for the left eye and another for the right eye.

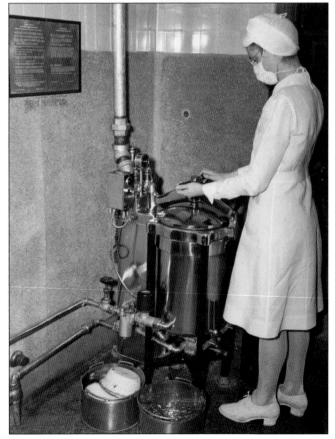

Modern pressure washers such as this one were used in the operating room in 1946. Other enhancements during the 1940s were stoplights placed outside the hospital entrance to control traffic, microphographic process (microfilm) in the medical records department, a basal metabolism machine, and a portable electrocardiographic machine. (Photograph by Harold Orne.)

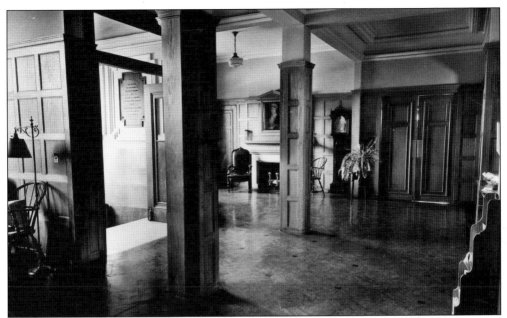

Faulkner Hospital's front lobby looked grand in this photograph from 1946. Improvements during the 1940s included the installation of explosion-proof wiring and the upgrade of coal stokers to the furnaces. The housekeeping department also began using nonskid wax in 1949. Faulkner Hospital proudly advertised in 1914 their use of Staples Floor Wax, which was made with imported premium grades of carnauba wax derived from Brazilian palm leaves. (Photograph by Maclardy.)

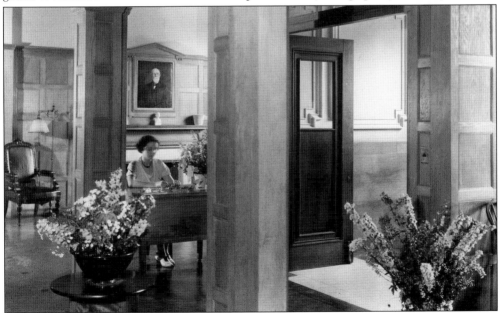

Following the recommendation of the Hospital Council of Boston, Faulkner Hospital was surveyed in 1946, when this photograph was taken. Labor Relations counselor Royal Parkinson delivered a personnel procedure booklet, which covered work hours, vacations, promotions, and other issues related to personnel. This booklet also included a "problem procedure" with a method for airing complaints.

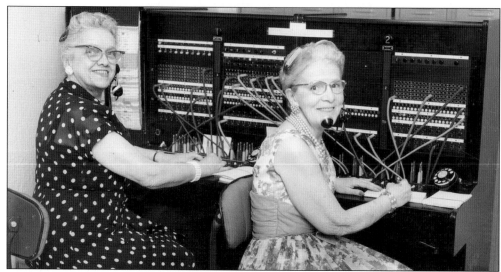

This photograph showcases the installation of the hospital's first intramural dial telephone system in 1945. The internal phone numbers even looked different; for example, the number for the blood bank was Ja-4-3200, with "Ja" for Jamaica Plain. During the 1970s and 1980s, the hospital telephone number was 617-522-5800. Phones were decorated in mod burnt orange and chocolate brown. Faulkner Hospital changed to its current phone number, 617-983-7000, in 1992. (Courtesy of Fay Foto.)

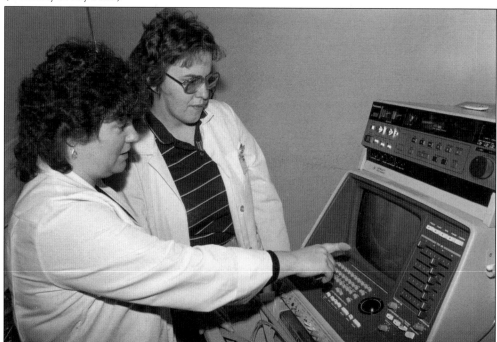

Tom Baggett shared his computer story with the community relations department. In the early 1960s, he installed the first-ever visible record computer in the country. Being accustomed to computer-related firsts, he was pleased to learn that a new computer system had been installed in Faulkner Hospital and that he was the very first patient entered into the system. This photograph shows a computer used in the cardiology department in 1987.

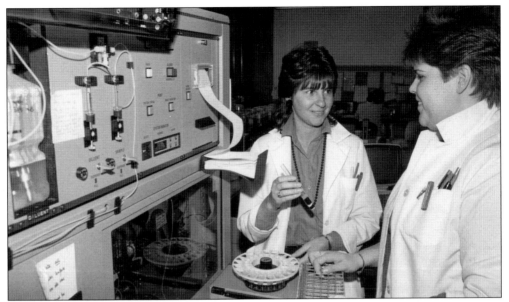

Computers and technology have certainly come a long way. This photograph shows chemistry technicians using state-of-the-art equipment in 1987. Automation through the years has included the IBM Electric Typewriter, the IBM MT-ST Automatic Programmed Typing Machine, MOSAICS (Medication Order Supply and Individual Charge System), and the Meditech Registration System. The first automated teller machine (ATM) was installed in 1985, and the first fax machine was installed in 1989.

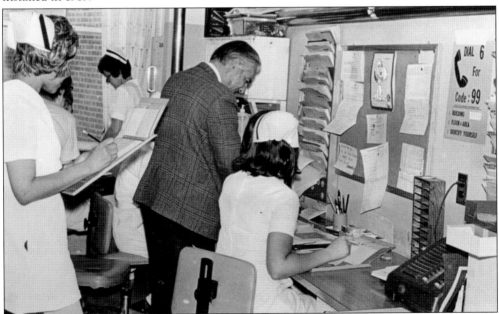

Today hospital personnel are used to Code Blue, Code Red, and even Code Pink. In 1966, Faulkner Hospital was one of the first to implement "Code 99." Through an operator-managed page system, changes in patients' conditions were delivered to anesthesia, nurses, inhalation therapists, residents, physicians, externs, and the surgeon on duty in the emergency operating room. When Code 99 blared through the loudspeaker system, everyone would rush to the scene.

What did people do before air-conditioning? At Faulkner Hospital, radiators were used as a cooling system. Patients could also rest near the hospital's 10 fans, which the hospital reported "gave refreshment to many patients during the heat of the summer." The first air conditioner was installed in 1952. One warm touch for snowy days like the one in the photograph was "Melt-O-Mats" for the ramps and front steps. (Photograph by Harold Orne.)

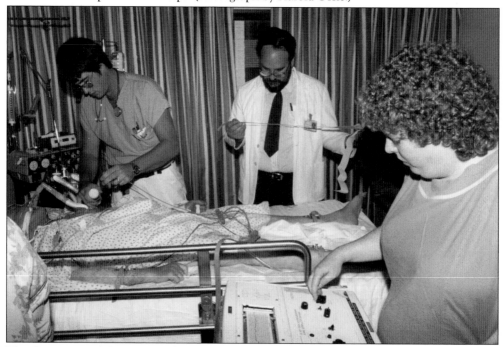

The Concentrated Care Center later became the intensive care unit and the critical care unit, pictured here. The Concentrated Care Center was one of the first patient care units to go "online" with the Meditech system. While Faulkner Hospital phased out smoking completely in 2010, back in 1984, smoking was permitted in some waiting areas, such as the Concentrated Care Center waiting room.

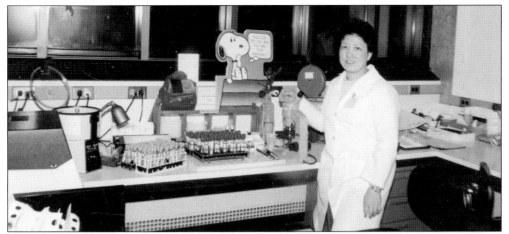

When Dolly Marmol (pictured) came to the blood bank in 1975, a bulky, antique Jewett refrigerator held the blood supply. She recalled that the microscopes used during that time did not have built-in lights, so staff had to use a lamp and aim a mirror to use them. Test tubes were not disposable, thus a designated person came in every day to wash them. (Courtesy of Dolly Marmol.)

It must have been especially loud in the early 1970s, because Faulkner Hospital convened a Noise Abatement Society whose function was "to search out and muffle noise in the hospital." A subcommittee of the society was the Bright Ideas Committee, whose function was "to have bright ideas about reducing noise in the hospital." The society determined that if each staff member cut noise by 1/20th of a decibel each day, Faulkner Hospital would be the quietest hospital there was. The project conducted a decibel study and found that the top five sources of noise were 1) paging system, 2) personnel, 3) noisy equipment, 4) visitors, and 5) the west elevator. While the Noise Abatement Society no longer exists, the Bright Ideas Committee has continued to develop and incorporate bright ideas for many other areas in the hospital. (Courtesy of Fay Foto.)

Faulkner Hospital was a founding hospital of Tufts Associated Health Plan. During the 1980s, the hospital offered a variety of insurance options, including Blue Cross Blue Shield, Harvard Community Health Plan, Multi-Group Health Plan, Medex, and Tufts. For selected plans, the hospital paid the entire rate, and the most expensive option was only $12.37 per week. During the 1990s, the hospital offered over a dozen plans. (Courtesy of Nocca Studios.)

In 1982, the hospital began to issue the familiar blue plastic ID cards for outpatient and emergency room services. The cards were imprinted with the patient's name, date of birth, and medical record number. An electronic embosser linked to the computerized patient information system to help increase the speed of the registration process. The photograph from 1987 shows that staff still used paper forms in areas like outpatient observation at the time.

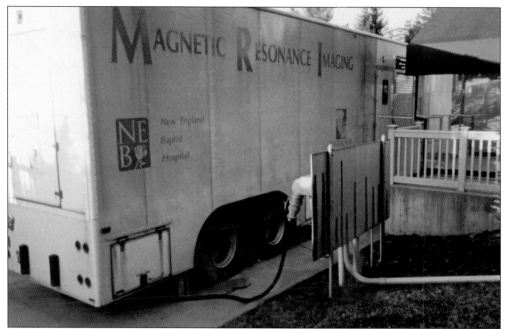

Faulkner Hospital shared joint ownership of a mobile MRI unit (the first of its kind in Boston) with the New England Baptist Hospital in 1987, and the Aurora Imaging MRI Clinic became available on campus in 1999. Faulkner Hospital was only the second site in the United States to host and operate the Aurora Breast MRI System. (Courtesy of Max Bermann.)

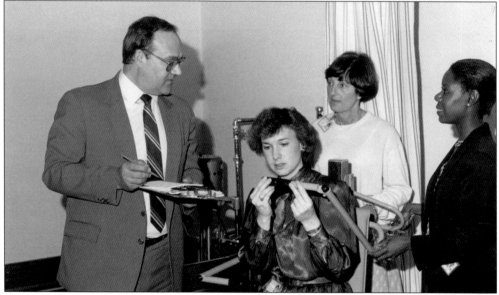

The hospital participated in the Massachusetts Health Quality Partnership, a statewide survey conducted by the Picker Institute that was the first initiative of its kind. The study looked at dimensions of patient care that patients identified as most important. Over 300 Faulkner Hospital patients participated annually. Faulkner Hospital performed at or above the national average in all dimensions of care. Here the safety committee inspection team is shown testing equipment for safety.

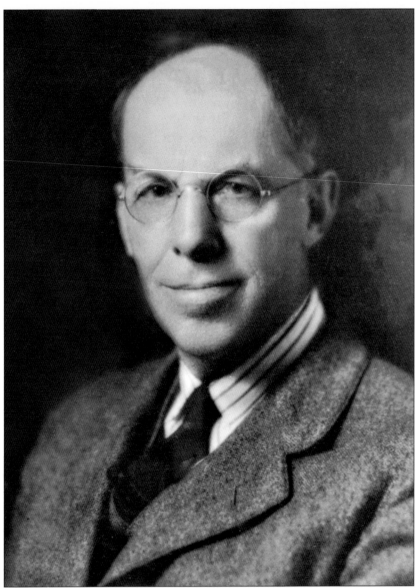

The hospital maintained libraries from the start. Marguerite Souther was a frequent volunteer librarian. One of its notable books has lasted over 100 years, an autographed version of *One's Self I Sing* by Elizabeth Porter Gould, who donated the book to the library in June 1906, a month before her death: "For the library of Faulkner Hospital, Jamaica Plain, Mass. with compliments." Early library supporters donated subscriptions to *Atlantic Monthly*, *Cosmopolitan*, and *McClure's*. Even Dr. Faulkner himself donated books and magazines, including *World's Work*, *Century*, and *Southern Workman*. The current medical library was named for Ingersoll Bowditch (pictured), who served as Faulkner Hospital's treasurer from 1908 to 1938. The early Ingersoll Bowditch Medical Library was similar to its counterpart of today. In 1942, there were 260 volumes of textbooks, which were accessioned, catalogued, and classified according to Boston Medical Library classification. Early acquisitions included *Cumulative Index* and *Nelson's Loose-Leaf Surgery*. There were 14 bound medical journals. The library was always open 24 hours a day and was, from the start, a non-lending library.

COOKIES. Plain or Fruit

MARY IRVING

2 pounds of flour	1 pound of butter
¾ pound of brown sugar	4 eggs
3 teaspoons of baking powder	1 teaspoon of vanilla

Rub well together the butter, sugar, and flour, sifted with baking powder, and mix with eggs and vanilla. To put in fruit, roll half the dough fairly thin, sprinkle with currants, then roll again until as thin as desired.

SUGAR COOKIES

MRS. W. O. WITHERELL

One-half cup of butter, creamed with one cup of sugar. Add two eggs, well beaten, and one-half teaspoon of soda, dissolved in three tablespoons of milk. Flour to roll thin.

DROP CAKES

MRS. F. C. JILLSON

½ cup of butter	1 cup of sugar
1 tablespoon of molasses	½ cup of milk
1 egg	½ teaspoon each of cinnamon,
1¾ cups of flour	nutmeg, and allspice
1 cup of chopped walnuts or	2 teaspoons of baking powder
raisins	

MOLASSES DROP CAKES

MISS ROSAMOND MAY

1 cup of sugar	1 cup of butter
2 eggs, yolks and whites beaten	1 cup of boiling water
together	2 teaspoons each of soda, ginger,
2 cups of dark molasses	salt, and cinnamon
6 cups of sifted flour	1 tablespoon of cooking Sherry

Mix well and drop from teaspoon on buttered tins. Bake only enough for one serving. Save dough in ice chest and bake fresh another time.

A treasure in the library's collection is the *Faulkner Cook Book*. Chapters in this 1914 "book of tried and true recipes" include soups, fish, meats, vegetables, salads, eggs, cheese, desserts, puddings, frozen desserts, breads, muffins, cakes, cookies, chafing dish recipes, fruits, pickles, preserves, confectionery, beverages, and sandwiches. Over 80 contributors provided their favorite recipes, including Maria Louisa Souther and Lillian Broughton. A sample recipe, submitted by Mrs. M. W. Richardson, informs the cook that "the usual method for mixing cake is to work the butter to a cream, adding the sugar gradually, then the beaten egg yolks, next the flavoring, and then the flour alternately with the milk until both are used. Last of all, fold lightly the egg whites, beaten stiff and dry." Speaking of cookbooks, a famous local cookbook author, Fannie Farmer, donated a copy of her own cookbook to the hospital in 1906. She operated Miss Farmer's Cooking School, which provided instruction to many of Faulkner Hospital's student nurses.

The Ingersoll Bowditch Medical Library houses the hospital archives, where Faulkner Hospital annual reports have been maintained back to 1903. Historic collections the library maintains include the John R. Graham Headache Collection, the Irving Zieper Neurology Collection, and the Michael G. Wilson Orthopedics Collection. The original bound lecture series of 1904–1905 has also been preserved. Hand-inscribed in ink by Helen J. MacCarthy, the series starts with Dr. Arthur Nicholson Broughton's lecture on etherization, which begins, "Ethyl-Oxide or Ether, as it is commonly called, is a derivative of Alcohol and Sulphuric acid, distilled. In order to give the best results, Ether should be kept absolutely fresh, kept in dark bottles in a cool place. It is highly inflammable and being heavier than air settles to the floor, therefore all lights or fire should be overhead. A damp cloth should be placed over the cone if a cautery is being used."

Dr. David Davis (pictured) was instrumental in the founding of the current Ingersoll Bowditch Medical Library, built in 1963. Upon his death, the David Davis Memorial Fund was established to provide books and an annual lecture in his name. Dr. Lloyd E. Hawes, chief of radiology, was chair of the library committee when the new room opened.

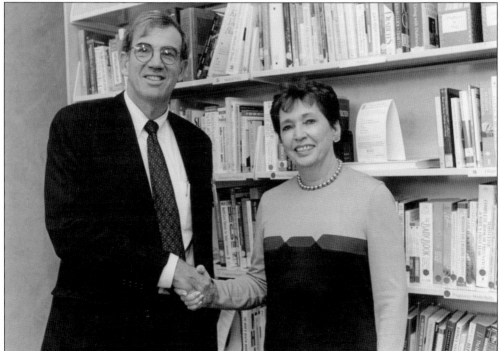

Patient/family resource rooms opened in 1998, and the Patient/Family Resource Center was launched in 1999. Diabetes and foot screenings were offered at the opening reception. The library's first database was MEDLINE Express on SilverPlatter CD-ROM. At first this system was only available on a trial basis and library director Barbara Pastan (pictured with Pres. David Trull at the P/FRC opening) urged staff to come in and search with it.

The hospital first published *Information for Patients* in 1929. Patients were distinguished as "free," "part pay," or "private," and those not considered free had to pay their bills weekly in advance. A view of many of the hospital's patient information brochures from the late 1990s, including a *Community Resource Guide for Seniors* and the *Patient Information Guide*.

This photograph shows the Patient/Family Resource Center in 1999. In 1931, the hospital founded the first patients' library, which contained over 700 volumes and distributed 50 books each week to patients. Like other programs in the hospital, the library committee was quite enterprising and sold about 200 of their oldest books in 1932 for the sum of $5 to buy newer books.

Today's Ingersoll Bowditch Medical Library provides about 400 print books, 200 electronic books, 100 print journals, and 400 electronic journals, with links to many more resources through its full-text databases. Here director of library services Cara Marcus reads one of her favorite books in the collection, a 1936 *Gray's Anatomy* donated by Dr. Michael G. Wilson. (Courtesy of Ed Marcus.)

Faulkner Hospital became fully accredited by the Joint Commission on Accreditation of Healthcare Organizations in 1954. A Service Excellence and Quality Council (SEAQ) was established in 1992. One of the council's early projects was to convene a series of focus groups of patients, employees, and physicians in an effort to identify what customers look for and to develop responses to their needs. (Courtesy of Mainframe Photographics.)

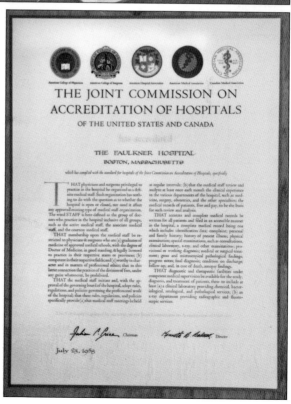

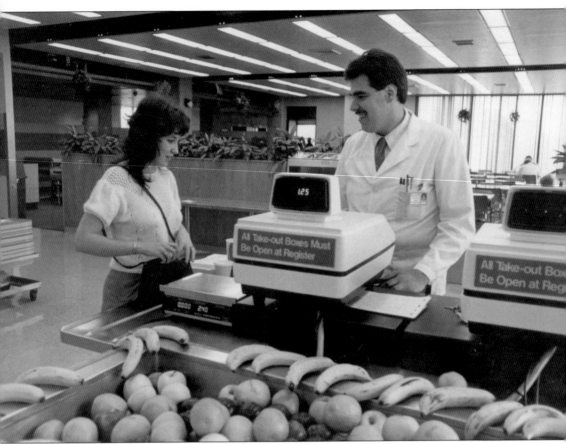

The hospital cafeteria, shown here in the 1980s, is known for hearty, wholesome, home-cooked meals, such as beef and turkey potpies and homemade meatloaf, and theme days like Italian, Caribbean, and Greek. Early offerings included a Dip-and-Dunk Basket, Delicious Club, Bermuda Triangle Sandwich, Sunrise Sandwich, and a cryptic offering called Dynamite. A 1971 menu included Seafood Newburg, Southern Fried Chicken, Cold Tongue, and Jell-O Molds. Cafeteria manager John Dantona (pictured) first came to Faulkner Hospital as a cook in 1977. Prices would put a smile on your face: 45¢ for coffee and 50¢ for a bagel. A trend in food design through the 1980s was to garnish everything with curly kale, so the salad bar was literally encased with this attractive garnish. The gourmet menus were heartily appreciated by diners, and Faulkner Hospital had a reputation for excellence in food among area medical students. "When I was a medical student here," recalled Dr. Daniel Matloff, "Faulkner Hospital was known for its spectacular food, especially the incredible smorgasbord served at the annual holiday meal." (Courtesy of John Dantona.)

Ruth Imbaro from patient information has worked at Faulkner Hospital for nearly 30 years and still remembers the special way the cafeteria made tuna melts back then: layered on English muffins with cheese and dressing and melted under a heating device until they were "just right." The all-time customer favorite through the years has been the real New England clam chowder.

The hospital's beautiful chapel, constructed in 1979, is framed by two floor-to-ceiling stained-glass windows by artist Lois Chartres and imported from France. The many shades of blue, orange, yellow, and red glass are inlaid in textural gray grout in an entrancing naturalistic pattern. James Lawrence was the chapel architect, and Fr. Charles McGahey, Rabbi Alan Turitz, and Rev. Blayney Colmore delivered the dedication. (Courtesy of Mainframe Photographics.)

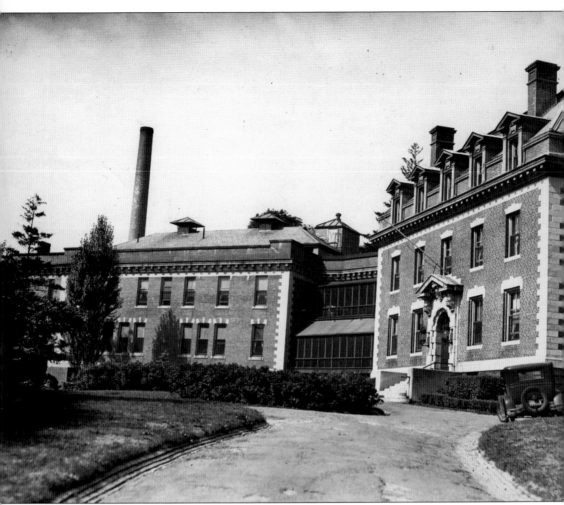

No matter how far technology has come, Faulkner Hospital still remembers its roots—literally! Some of the trees that graced the first hospital grounds still provide shade for the buildings and paths. The horse chestnut and linden trees near the front of the hospital and the red maple tree near the service and delivery entrance were there when the hospital was first built, according to Deb LaScaleia, grounds supervisor. Other trees were planted as tributes through the years, such as the red maple and weeping cherry tree planted on the back lawn in memory of Faulkner Hospital volunteers. And many have remained, including stately maples, forsythia, oak, and birch, which have been known to shelter rabbits, woodchucks, and even possum. Some other remnants of days of old still turn up on the grounds—daffodils that come back year after year and pieces of coal from the days before oil heat.

Seven

GIVING BACK
TO THE COMMUNITY

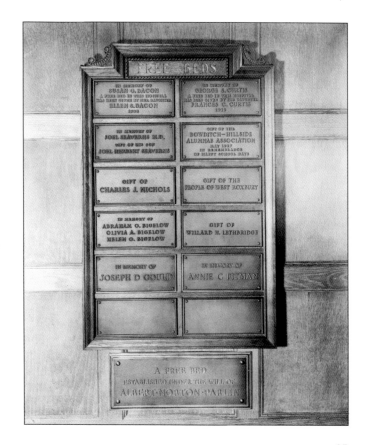

Faulkner Hospital was designed for residents of "Old West Roxbury," and all visitors were welcomed. A number of thriving funds had been set up to benefit the hospital: General Fund, Robert Charles Billings Fund, Hospital Music Fund, West Roxbury Free Bed Fund, George S. Curtis Free Bed Fund, Bowditch School Free Bed Fund, and Susan G. Bacon Fund. By 1915, over half-a-million dollars had been raised through these funds.

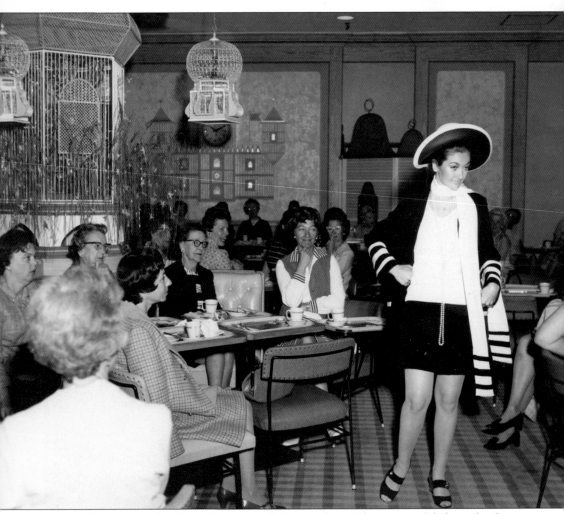

The Faulkner Hospital Aid was later named the Auxiliary. This group of dedicated volunteers contributed in a myriad of ways to benefit Faulkner Hospital. "The Auxiliary's contributions really made a substantial difference in the patient experience here at Faulkner Hospital," stated Rosemarie Shortt, director of patient/family relations. "Their concerted efforts at determining how patient stays could be made more pleasant were admirable." The Auxiliary members were masters at fund-raising, baking cookies to sell before Thanksgiving, and hosting flower sales. Proceeds went to the Patient Needs Fund, which funded services like cable television for all patient rooms, automatic blood pressure machines in the intensive care unit, geriatric chairs, Hoya lifts, blanket warmers, and an eye exam chair for the emergency department. The Auxiliary raised funds for the hospital-owned Village Manor Nursing Home and had two benches installed in the home's gardens. The annual fashion show (shown here) was always an exciting event. The committee members looked elegant as they modeled the latest fashions. Notable speakers were Beth Germano of WBZ-TV 4 and Susan Wornick of WCVB-TV 5. (Courtesy of Nocca Studios.)

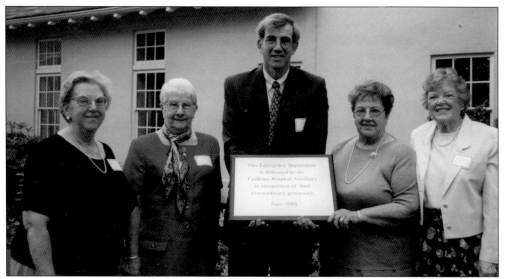

The following poem can be attributed to Lillian Caskie, president of the Faulkner Aid in 1964: "Someone has blended the plaster, / Someone has carried the stone, / Neither the man nor the master / Ever builded alone. / Building a room from the weather, / Or building a house for the king, / Only by working together / Can we accomplish anything." The image shows Faulkner Hospital Auxiliary secretary Marie Romanos, officer Isabel Johnson, auxiliary president Eugenia Romanos, and treasurer Mary Kane receiving an award from Faulkner Hospital president David J. Trull.

The Nurses' Alumnae Association managed the Sun Room Gift Shoppe in the 1950s, which raised funds for both patient and employee needs. The shop offered a personalized flower service. Another popular fund-raising effort from that time was a baby picture service, sponsored by the Aid. The Aid opened a new gift shop in the early 1960s and circulated gift cart and craft cart services to patients. (Courtesy of Fay Foto.)

Mrs. James Kenney, Aid president, discusses the gift shop's wares with director Paul Spencer in this 1961 photograph. The shop has always been staffed by dedicated volunteers. Madeline Smith, who has volunteered for 19 years, shares, "Students I had once taught in kindergarten are now employees at The Faulkner, and they still recognize me! Parents, neighbors and friends always drop in with kind words about the 'Best Hospital Gift Shop.'"

Many Faulkner Hospital employees remain in "The Faulkner Family" for 20, 30, or even more years. The hospital honors their loyalty with service awards and special pins. During the 1980s and 1990s, award ceremonies took place at the John F. Kennedy Library in Boston. Volunteer Rosalie Murphy created stunning watercolors to celebrate those at Faulkner Hospital serving for many years, like this illustration of the city of Boston. (Courtesy of Rosalie Murphy.)

The logo of the 1990s was a stylized modern rendering of the hospital, the hill, and the surrounding trees. Created by Lapham/Miller in 1989, the design was said to highlight the clinical advantages of a teaching hospital combined with the friendliness and compassion offered in a community setting. This logo adorned custom embroidered scrub wear, athletic shirts, caps, and this key ring. (Courtesy of Mainframe Photographics.)

Dr. George Faulkner endowed the hospital with this creed: "The patient is at the hub of the wheel." The early hospital crest displayed the Faulkner family motto *Armis Potentius Aequum*, meaning "justice is more powerful than arms." A new seal created in 1956 is shown here on a plate presented to Faulkner Hospital physicians in honor of their service. (Plate donated by Pardon Kenney; photograph courtesy of Mainframe Photographics.)

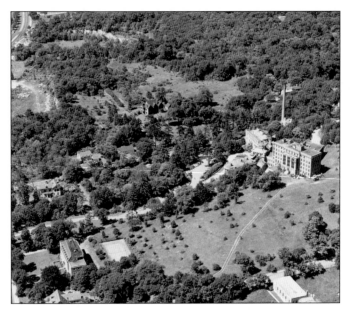

Faulkner Hospital has provided numerous educational opportunities to the surrounding communities. A sampling of Sunday afternoon health talks included "Girth Control" with Dr. Arthur A. Cushing and "Surgical Diseases of the Kidney and Bladder" with Dr. Edward L. Young Jr. Programs that have been held through the years include the David Davis Memorial Lecture, the Paul Bettencourt Lecture, and Edward L. Young Lecture. (Photograph by Eastern Aerial Surveys, Inc., Boston.)

The hospital displayed leadership in community outreach, sponsoring essay contests for junior and senior high schools in Jamaica Plain and the surrounding areas and hosting Career Days for Horizon Club Campfire Girls. Faulkner Hospital also hosted variety shows at local schools, and Girl Scout troops served as junior volunteers, delivering flowers and serving trays and brightening the days of patients.

A mobile glaucoma screening program was a valuable community service. Other programs included transportation for people of limited mobility, which provided visits to doctors and essential shopping trips, and a dinner-and-recreation program provided seniors with films, dancing, and games. A mobile van program for patients with respiratory problems, Breath of Fresh Air, took patients to movies, museums, and malls. It was equipped with back-up respiratory equipment and was wheelchair accessible.

Volunteers contribute to the hospital in many ways. Their valuable services have included bingo games, sing-alongs, scout troop tours, and the Patient Needs Fund, which funded everything from televisions for dialysis patients to comfortable jackets for low-income patients. Volunteers in this photograph from 1993 include Evelyn Bamford, Bob Bunai, Louis Cashman, Lorraine DeVergilio, Michael Freedman, Bill Gorman, Kay Pfau, Jane Pierce, Steve Ricci, Mary Rudman, Elwood Sweeney, and Al Weiner.

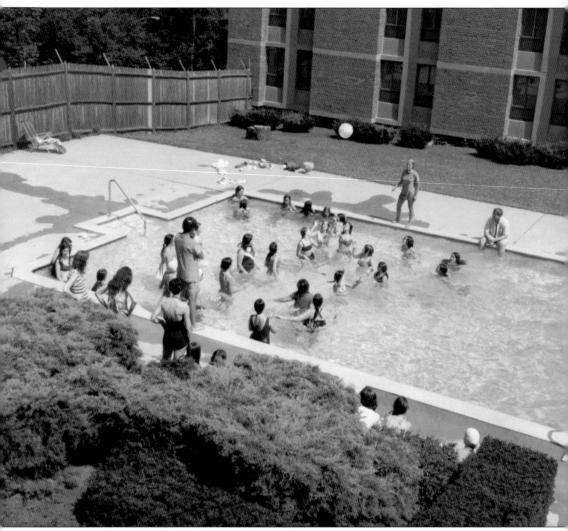

Working at Faulkner Hospital went far beyond the day's assignments. Staff and students participated in many activities that made Faulkner Hospital a fun place to be, such as sleigh rides and a bowling team. The Faulkner Follies was a competition between various Faulkner departments that benefited the United Way. Players had a chance to try their hand at a "disaster drill race" with mops, safety manuals (which were quite heavy), shoes, and balls. If that was not exciting enough, they could race in full operating room uniforms by tricycle or brave the main lobby golf course. From the 1960s to the 1980s, a 52,000-gallon pool, built by the Continental Swim Pool Corporation, was open day and night. Every summer the hospital hosted a fabulous party, where the piece de resistance was watching the attending physicians push the service chiefs into the water. (Courtesy of Nocca Studios.)

Eight

BUILDING THE "NEW" FAULKNER HOSPITAL

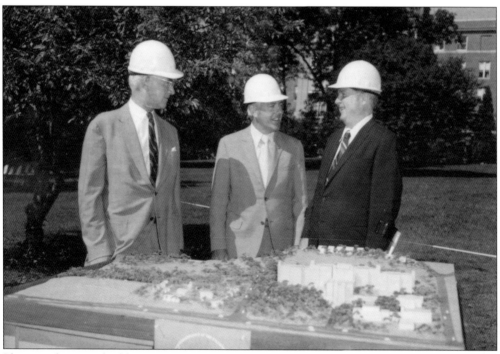

Planning for a new building to meet Faulkner Hospital's growing demands began as early as 1950. Through the years, committees—the Hospital Improvement Committee, Committee on Future Development, and even the Size Committee (its actual name)—met, planned, and discussed how the building would proceed. On January 23, 1968, the trustees requested architects Perry, Dean, and Stewart to undertake a master development plan, which was accepted 11 months later.

Looking at these two photographs of Faulkner Hospital, the above from 1976 and below from 1988, illustrates the difference between the old and the new. Some novelties through the years included a horse-drawn barge in 1909 and electric beds with push-button controls and automatic bedpan washers in the 1950s. In 1958, an audio-visual patient-to-nurse communication system was installed on each floor. That was the year the hospital changed from coal to oil heating, eliminating shoveling and ash removal. A fire alarm system of boxes and gongs connected the hospital with fire headquarters in 1962. Completing the groovy 1960s was the purchase of a water bed. Before you even start to wonder why—its purpose was to treat patients with decubitus ulcers.

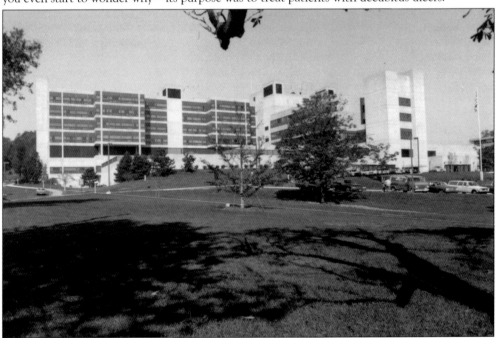

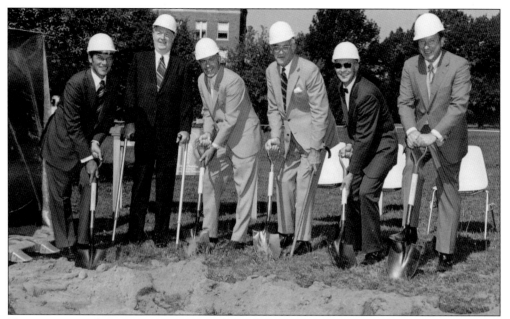

Not everyone in the community supported the idea of a new building, but many residents donned "Save the Faulkner" bumper stickers on their cars to show their support of the planned renovations. It was mandated by the Public Health Council that the old hospital was to be demolished upon the building of the new hospital. The Public Health Council granted the hospital the right to expand in 1973.

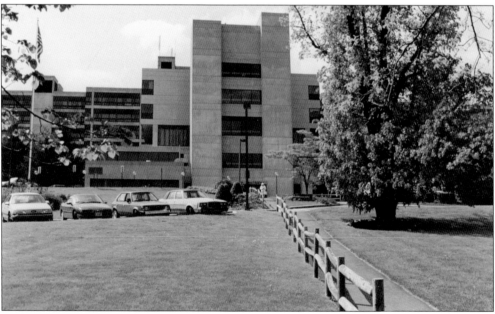

In 1973, the loan for construction was approved by the U.S. Departments of Housing and Urban Development and Health, Education, and Welfare. Plans were designed by architects Perry, Dean, and Stewart. The new hospital, completed in 1976 at a cost of $44 million, was seven stories high and 300,000 square feet, with 259 beds and an emergency room 10 times larger than the old one.

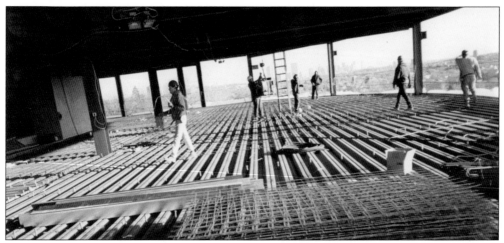

Paul Keating, director of facilities, recalls many of the challenges in undertaking such a large and complex building project. "We had to deal with the existing structural concrete and the challenges of adding on to an occupied hospital building, including uncovering the original waterproofing material originally applied below grade, which needed to be encapsulated," said Paul. "Also, we wanted window assemblies that would not leak, so they were recessed into their openings. We used precast concrete exterior wall panels imported from Newfoundland. The exterior panels were sent to us with unique numbers, so they could be assembled similar to a child's erector set. We never stopped working. We even worked on the structural steel and concrete through the winter, using portable propane heaters both to stay warm and to allow the materials to set correctly."

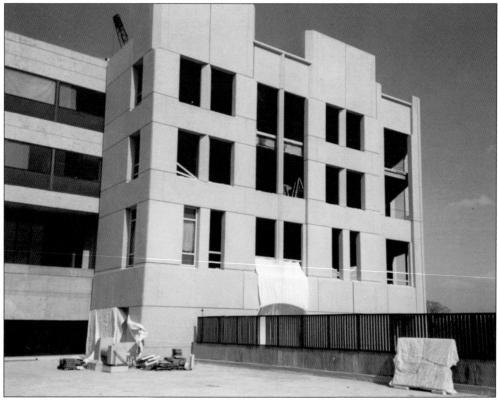

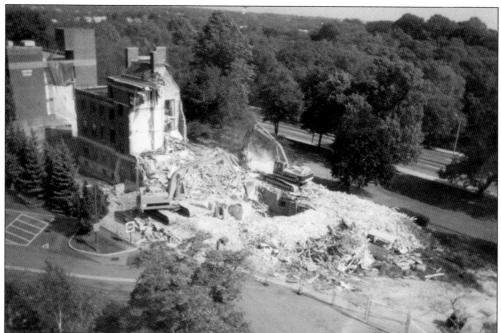

Everyone eagerly awaited the "New Faulkner," and construction workers took students on tours of the building while in progress. Nursing students posed amongst the beams wearing hard hats for special yearbook photographs. The human resources department planned informational bulletin boards on every floor. There were a few delays, such as a water main flood that was so severe that the fire department was called in to help, but the construction generally went smoothly.

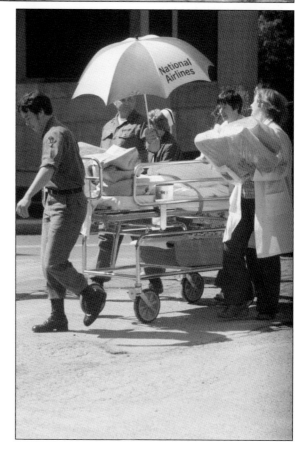

Moving day, known as "M-Day," was Saturday, May 22, 1976, the same day Paul McCartney gave a concert at the Boston Garden. What Dr. Andrew Huvos remembers was how some patients had to be manually ventilated with respirators between the two buildings. Dolly Marmol remembers packaging the blood supply in Styrofoam boxes on ice and installing a temporary blood bank in case someone needed blood that day.

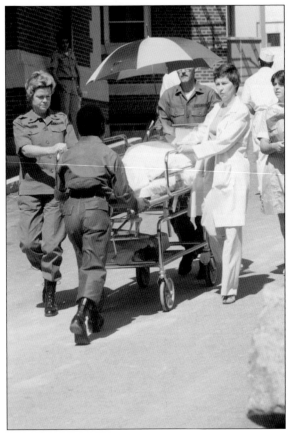

M-Day was on the news, recalls Frank Frey from security, who watched himself and others on television that night. The weather was lovely, and the National Guard was in place to help with any needed communications. Everyone who worked at Faulkner Hospital on M-Day was given a job. Mimi Iantosca's job was to visit patients after they were moved and make them feel more at home. The staff really wanted to make everyone welcome and comfortable in the new setting. At the end of the day, one patient reassured her, "I have been welcomed to my new room so many times, but I am fine! Please don't worry anymore, everything is fine!"

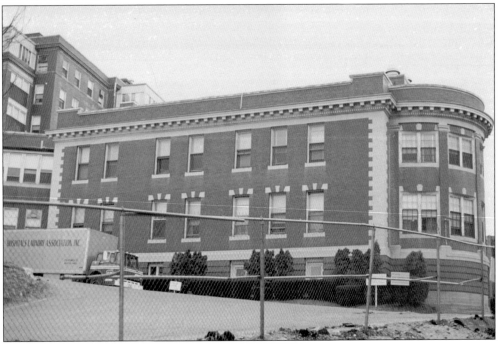

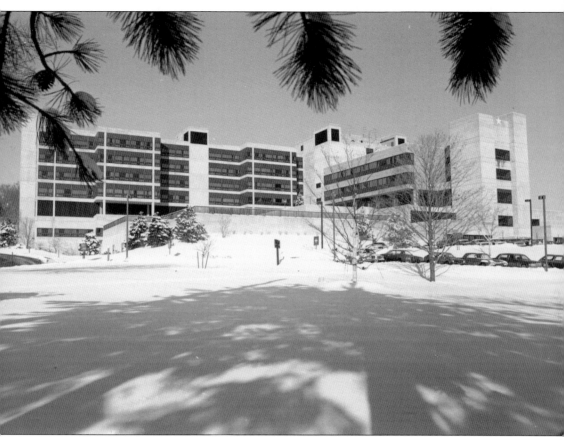

The new building spurred a number of innovative ideas based on Friesen design. Hospitals designed using the concepts of architect Gordon Friesen were focused on reengineering for patient-centered care. Nurses' stations were eliminated and replaced by administrative control centers and team conference centers. With nurse alcoves and Nurservers (locked supply cabinets) in each patient room, the conceptual idea was for each room to become a "self-contained little hospital." Nurservers even had special airflow mechanisms to prevent infection. Another concept was an automatic cart transportation system to deliver supplies and patient meals throughout the hospital via monorail conveyer. Rotating complement carts were attached to the monorail, which would also transport soiled supplies for disposal or deprocessing. Pneumatic tubes transported messages, such as doctor's prescriptions, by a whoosh-air mechanism at a rate of 30–35 feet per second. Patient units also contained intercom stations and physician dictation centers.

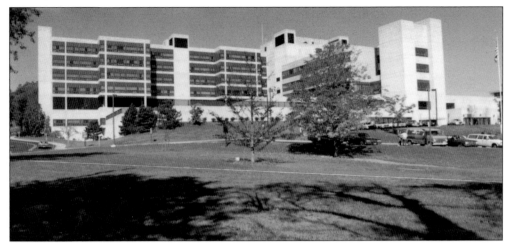

Today's Faulkner Hospital campus spans over 16 acres and the hospital buildings encompass about 500,000 square feet. The hallways in the new building were so long that one of the respiratory therapists traveled from room to room on roller skates with his equipment in a knapsack. A hint of the hospital's earliest sun porches still remains with a rooftop dining area equipped with umbrellas.

A shuttle bus to and from lots on Allandale and Centre Streets was introduced in 1970. A new garage opened in 1973; festivities included a ribbon-cutting ceremony and a cake with an icing illustration of the garage itself. Faulkner Hospital president John Blanchard drove the first car into the 580-car garage. In 1995, Boston mayor Thomas Menino led a ribbon-cutting ceremony to mark the opening of the new addition facing Centre Street.

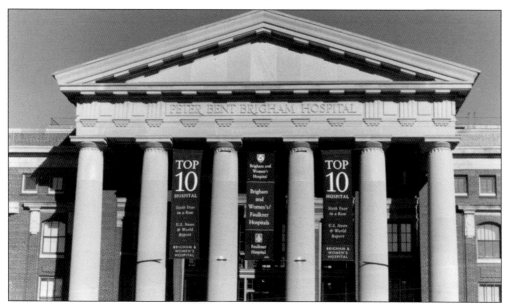

In the 1990s, the Strategic Initiatives Group (SIG) was formed to identify strategies to maximize the success of Faulkner Hospital. Extensive deliberations concluded that a merger with Brigham and Women's Hospital (BWH) offered the best value to patients and staff. The merger allowed Faulkner to continue its teaching focus by establishing integrated residency programs. Importantly, BWH made significant commitments to bringing expanded as well as new programs to the Faulkner campus.

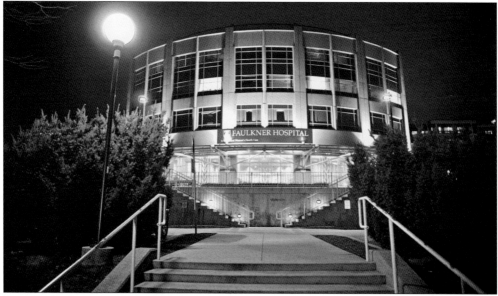

In 1998, Faulkner Hospital established an affiliation agreement with Partners HealthCare System and Brigham and Women's Hospital to become Brigham and Women's/Faulkner Hospital. This relationship allowed for the development of complementary services and for care of patients to be directed to the most appropriate hospital. The partnership was based on the philosophy that the programs of both institutions supplement one another, enabling success in a competitive environment. (Courtesy of Mainframe Photographics.)

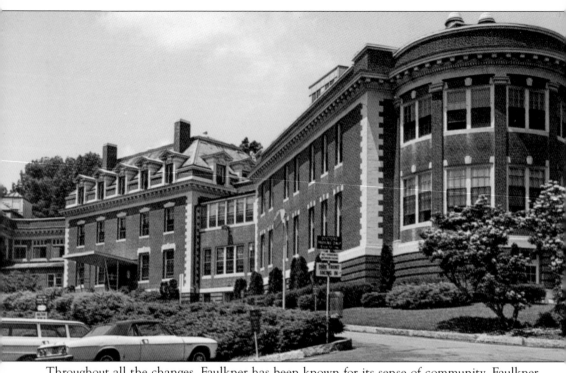

Throughout all the changes, Faulkner has been known for its sense of community. Faulkner Hospital looks warm and welcoming in this postcard from 1968. "Ode to the Faulkner" by Jane Pinanski sums it up nicely:

If I ever needed a hospital
There is only one place I would go,
Where the people are the pleasantest
Of anyplace I know

The nurses are always very kind
The doctors are the best.
They always tend to all your needs,
They never seem to rest.

You are never kept waiting
If you really are in need,
And volunteers come around with cart
If a book you want to read.

If you like eating
The food just can't be beat,
And if you want something special
They'll try to get you a treat.

You can even have a TV set
And maybe a telephone,
So your friends can call on you
And you'll never be alone.

Of course you know this Hospital
Where everyone is so kind.
It is Faulkner in Jamaica Plain
It's the best one you can find.

Nine

FAMOUS FAULKNERITES

Susan Torrey Revere Chapin, wife of Henry Bainbridge Chapin (original Faulkner Hospital board member) was the great-granddaughter of Paul Revere. She turned the first spade of earth to commence the hospital's groundbreaking. Susan Chapin was a dedicated board member and hospital supporter. Their son, John Revere Chapin, also served on the Faulkner Board. A fitting tribute was a Paul Revere bowl donated to Chapin House. (Courtesy of Forest Hills Cemetery.)

The Employee Activities Committee brought world-class talent to Faulkner Hospital. In 1972, Arthur Fieldler, conductor of the Boston Pops Orchestra (second from right) is pictured with Employee Activities Committee members Georgiana Tynan, Laura Page, and Edna Herbert before he and the Boston Pops performed at Faulkner Night at the Pops at Symphony Hall.

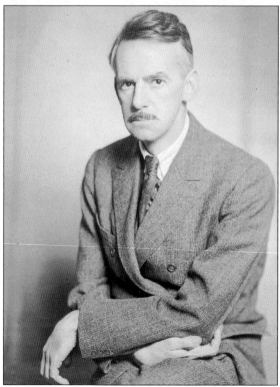

Eugene O'Neill (1888–1953), foremost American dramatist and Nobel and Pulitzer Prize–winning playwright, was a patient at Faulkner Hospital in 1951. The *New York Times* headline stated, "O'Neill Reported 'Much Better,'" following his stay at the hospital. The photograph shows O'Neill in 1927. (Photograph by Nickolas Muray; courtesy of www.eoneill.com and the Hammerman Collection.)

The hospital hosted many memorable concerts throughout the years to benefit the Faulkner/Sagoff Breast Centre. Diahann Carroll (pictured), Tony Award and Golden Globe Award–winning performer, entertained Boston with an unforgettable concert at Symphony Hall. The incomparable Ella Fitzgerald sang with her trio and a 26-piece orchestra at Symphony Hall. Other concerts featured folk singer Judy Collins, jazz great Mel Tormé, Leon Merian, The Divine Duppies, and the Shirelles.

Faulkner Hospital's own musically gifted staff has performed over the years, including Dr. Irwin Mirsky on bass fiddle and Dr. Wilfred Rounseville on the saxophone during the 1960s. Shown in the photograph is Eddie Marquez from materials management, or "Eddie Elvis" as he likes to call himself, who has mesmerized staff each year at the Winter Ball with his renditions of "Love Me Tender" and other Elvis Presley hits.

Thirty-three Faulkner Hospital employees debuted in the award-winning 1981 MGM film *Whose Life Is It Anyway*, starring Richard Dreyfuss and John Cassavetes. Actors included Ruth Imbaro, John Dantona's father Joseph, and Dr. Alberto Ramirez. Dr. Daniel Matloff was cast as an EMT on his second day working at Faulkner Hospital, but alas, not a single part of that scene made the movie. (Courtesy of Mainframe Photographics.)

Faulkner Hospital appears in a number of books. A nurse in Robert Parker's *Thin Air* (copyright 1994, used by permission of G. P. Putnam Sons, a division of Penguin (USA) Group, Inc.) worked at Faulkner Hospital, and a baby in Anita Shreve's *The Pilot's Wife* (copyright 1994, used by permission of Little, Brown, and Company, a division of Hachette Book Group, Inc.) was born at the hospital. (Courtesy of Mainframe Photographics.)

TED WILLIAMS *affirmed his status as one of the game's top hitters with a .406 average.*

A number of athletes came to Faulkner Hospital. Boston Red Sox outfielder and the American League's triple-batting champion Ted Williams (pictured) was a patient in 1942 as publicized in the *Luddington Daily News*. (Permission to use the name and image of Ted Williams courtesy of Ted Williams Family Enterprises, Ltd., www.tedwilliams.com.)

In the Briefcase Race at Loon Mountain each March, Channel 5 sportscaster Mike Lynch (center) announces as skiers dressed up in business suits carry briefcases as they race down the mountain. Prizes have been awarded for the worst suit, tackiest tie, most impressive crash, and best excuse for a poor time. This event takes place in conjunction with WCVB-TV, Mix 98.5, and the TJX Foundation and raises funds for the Faulkner/Sagoff Breast Centre.

In 1982, two Faulkner Hospital physicians, Dr. Norman Sadowsky and Dr. Robert Eyre, played against tennis greats Bobby Riggs and Bud Collins in a match at the Longwood Cricket Club before the U.S. Senior Championship. This hospital fund-raising match was very well attended and a great deal of fun. The above photograph shows Dr. Eyre, Bud Collins, Paul Cook (president of the Longwood Cricket Club), Dr. George Starkey, Bobby Riggs, and Dr. Sadowsky. The photograph at left captures a great serve by Dr. Sadowsky, who will never forget one of Bobby Riggs's serves, which had such a great spin that it landed in his court and bounced back to the other side of the net before he had a chance to return it. (Courtesy of Norman Sadowsky.)

A Faulkner Hospital patient, Jessamine Gordon Warren, was the daughter of the artist who painted a glorious painting of Dr. George Faulkner that hangs in the Sadowsky Conference Room. The artist, Emeline Hastings, completed the painting in the late 1800s, but neglected to sign her work. Although she had often planned to visit the hospital some day to sign it, she died before she was able to. Emeline Hastings was a graduate of the Museum of Fine Arts and the portrait was her first commissioned work. Jessamine Warren remembers viewing her mother's painting in the waiting room of the "old" hospital. The painting of Dr. Faulkner, along with the painting of his wife, Abby Faulkner, were restored and framed with soft satin frames with crackle-gold finishes. (Courtesy of Mainframe Photographics.)

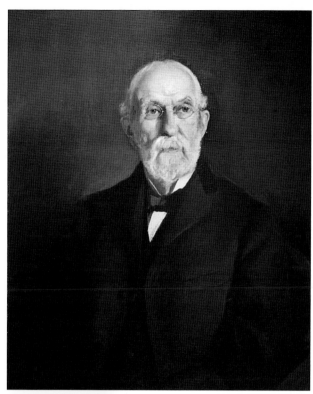

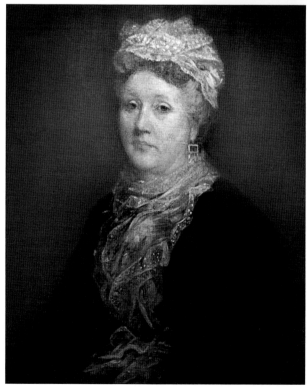

Dr. J. Martin Woodall, Medical Director of Adams Nervine from 1935 to 1966, shared the story of the magnificent clock (shown here) on display in the Faulkner Hospital Admitting Department. The 1895 Shreve, Crump, and Low clock was given to Faulkner Hospital in gratitude to Dr. Woodall for his care. Another clock, placed in the Gutierrez Medical Staff Lounge, was donated by the family of Dr. Irving Zieper. (Courtesy of Mainframe Photographics.)

Artwork by well-known artists graces Faulkner Hospital, including works by Donald Demers, George Eisenberg, Susan Schatter, Neil Welliver, William T. Williams, and Jack Wolfe. Staff and volunteers have donated stunning works of art. Auxiliary member Anne Quinlan's painting of Boston's swan boats beautifies the gastroenterology department. This lovely painting is by Dr. Raymond Murphy, who has donated many of his works to the Patient/Family Resource Center. (Courtesy of Mainframe Photographics.)

Ten

HAPPY BIRTHDAY, FAULKNER HOSPITAL!

When Faulkner Hospital celebrated its 100th birthday on December 5, 2000, it was a party to remember. Mayor Thomas Menino issued a city proclamation declaring December 5 as "Faulkner Hospital Day." People born at Faulkner Hospital gave permission to have their birth certificates displayed in glass cases. Nursing school alumni shared a special reunion. Guests enjoyed two centennial birthday cakes that depicted the old and new hospitals. (Courtesy of Mainframe Photographics.)

To celebrate Faulkner Hospital's milestone centennial birthday, *A Tradition of Caring Continues*, a beautifully designed booklet, was published and distributed to the community. The Faulkner Hospital Auxiliary produced limited-edition golden collector's ornaments (shown below) of the new hospital building. Framed, commemorative postcards of the 1905 Faulkner Hospital were given to staff at the time of the ceremony. At the birthday gala, welcoming remarks were delivered by the chairperson of the board, Mary Ann Tynan, and president, David Trull. Sandy Williams, a Faulkner family descendent, was a special guest of honor. The *Parkway and West Roxbury Transcript* newspaper featured the story, "Happy Birthday: Faulkner Hospital Celebrates Centennial." (Below, courtesy of Mainframe Photographics.)

Bruce Mattus, director of respiratory therapy, is shown here in a reenactment of Dr. George Faulkner at the Centennial Celebration. He stands behind a full-length banner created for the centennial event that boasts a photograph of Dr. George Faulkner holding his signature top hat. The motto "A Century of Caring" pays tribute to all who have cared for Faulkner Hospital patients during the first 100 years. (Courtesy of Bruce Mattus.)

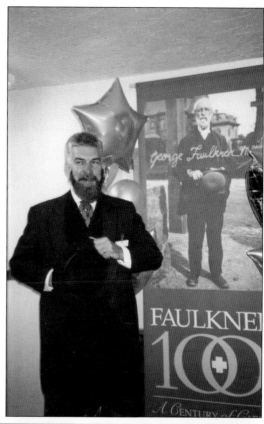

A time capsule was implanted in the wall of the third-floor lobby above the Faulkner Hospital dedication plaque, similar to a time capsule that was buried in the original hospital building. Twenty-seven departments placed items in the capsule, to be opened on December 5, 2100. Apparently, time capsules were a Faulkner family tradition, as Martha Faulkner, wife of George's brother Luther, buried several in Billerica.

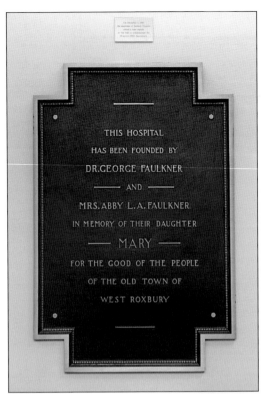

The time capsule preserved a snapshot of Faulkner Hospital in the year 2000. Treasures included coins minted in 2000, the day's *Boston Globe*, a CD-ROM drive, a nasopharyngeal airway, an empty box of Sensocaine, and a patient menu. Many of the departments also donated group photographs, business cards, and brochures about their services. (Courtesy of Mainframe Photographics.)

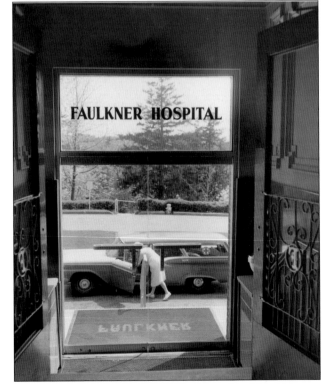

What makes Faulkner special? The hospital is known as "The Friendly Faulkner." "The Faulkner Hospital has a good family spirit," stated director Gerald F. Houser. "We recognize each other as human beings." Director Paul J. Spencer reflected Dr. Houser's sentiments, "The spirit of the organization is high. The friendliness and personal touch so prevalent throughout The Faulkner makes it a happy place in which to work." (Courtesy of Fay Foto.)

"Compassion and care are what we give here," stated Dolly Marmol, pictured in this 1978 photograph. "Everyone is so friendly and easy to get along with. We all work as a team!" exclaimed Frank Frey, security officer. Dan Massarelli has worked in the facilities department for 22 years. When asked about his favorite aspect of the job, Dan replied, "Definitely the people!" (Courtesy of Dolly Marmol.)

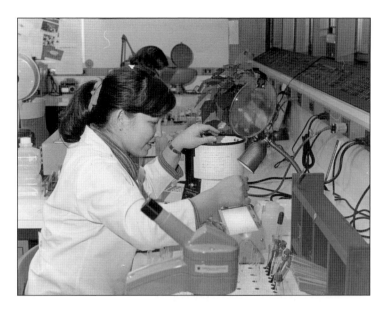

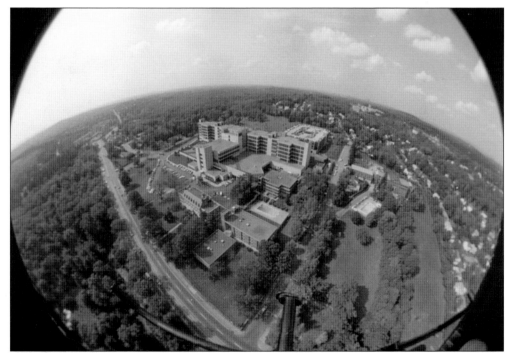

This aerial photograph of Faulkner Hospital shows how much the hospital has grown since its initial design, as well as how central it is to the communities it serves. While this historical narrative spans the hospital's centennial history from 1900 to 2000, new programs, services, and innovations in patient care are a hallmark of Faulkner Hospital. To find out more about Faulkner Hospital, visit www.faulknerhospital.org.

www.arcadiapublishing.com

MAP SEARCH

Discover books about the town where you grew up, the cities where your friends and families live, the town where your parents met, or even that retirement spot you've been dreaming about. Our Web site provides history lovers with exclusive deals, advanced notification about new titles, e-mail alerts of author events, and much more.

MADE IN THE **USA**

Arcadia Publishing, the leading local history publisher in the United States, is committed to making history accessible and meaningful through publishing books that celebrate and preserve the heritage of America's people and places. Consistent with our mission to preserve history on a local level, this book was printed in South Carolina on American-made paper and manufactured entirely in the United States.

This book carries the accredited Forest Stewardship Council (FSC) label and is printed on 100 percent FSC-certified paper. Products carrying the FSC label are independently certified to assure consumers that they come from forests that are managed to meet the social, economic, and ecological needs of present and future generations.

FSC
Mixed Sources
Product group from well-managed forests and other controlled sources

Cert no. SW-COC-001530
www.fsc.org
© 1996 Forest Stewardship Council

Find Your Place in History.